Thank you for choosing Jade Summer®.

Jade Summer® is a brand owned by Fritzen Publishing LLC, represents the work of multiple artists, and is registered in the U.S. Patent and Trademark Office.

Have a question? Please visit JadeSummer.com to learn more and send us a message.

We hope you have a great experience with this book and we appreciate your support.

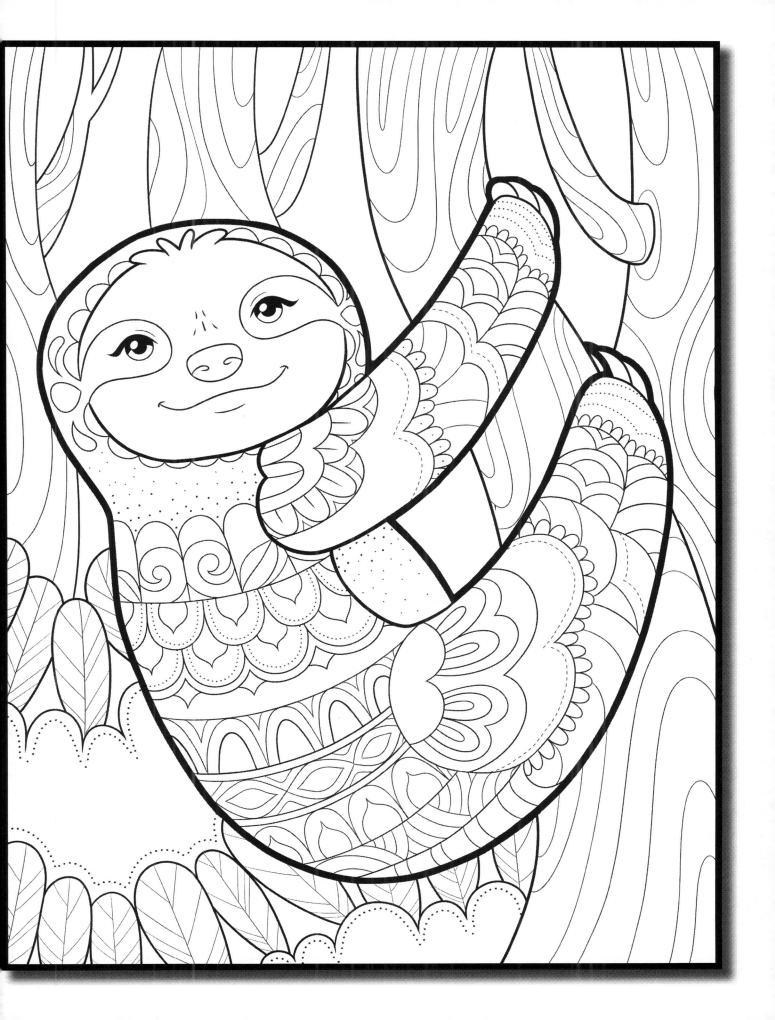

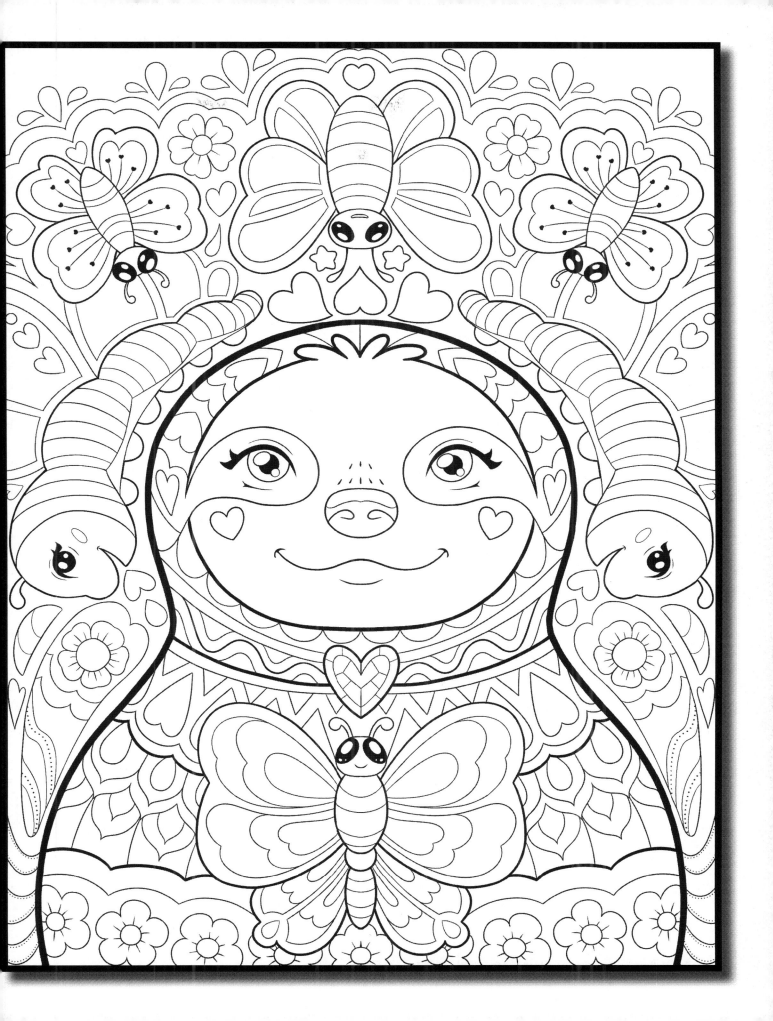

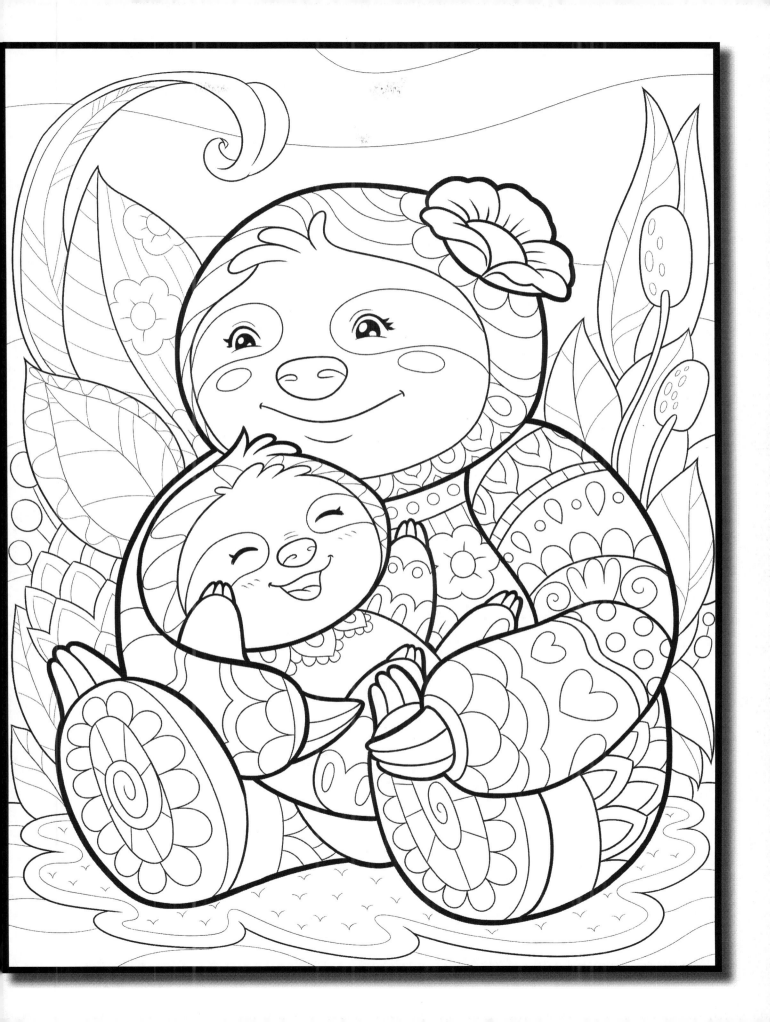

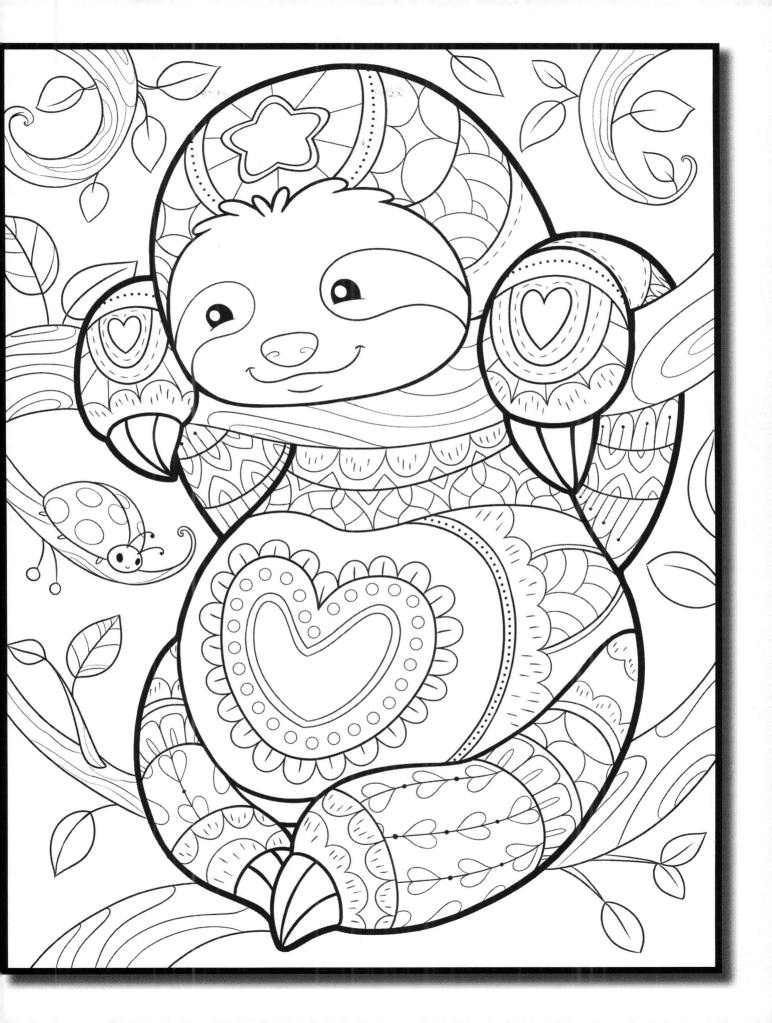

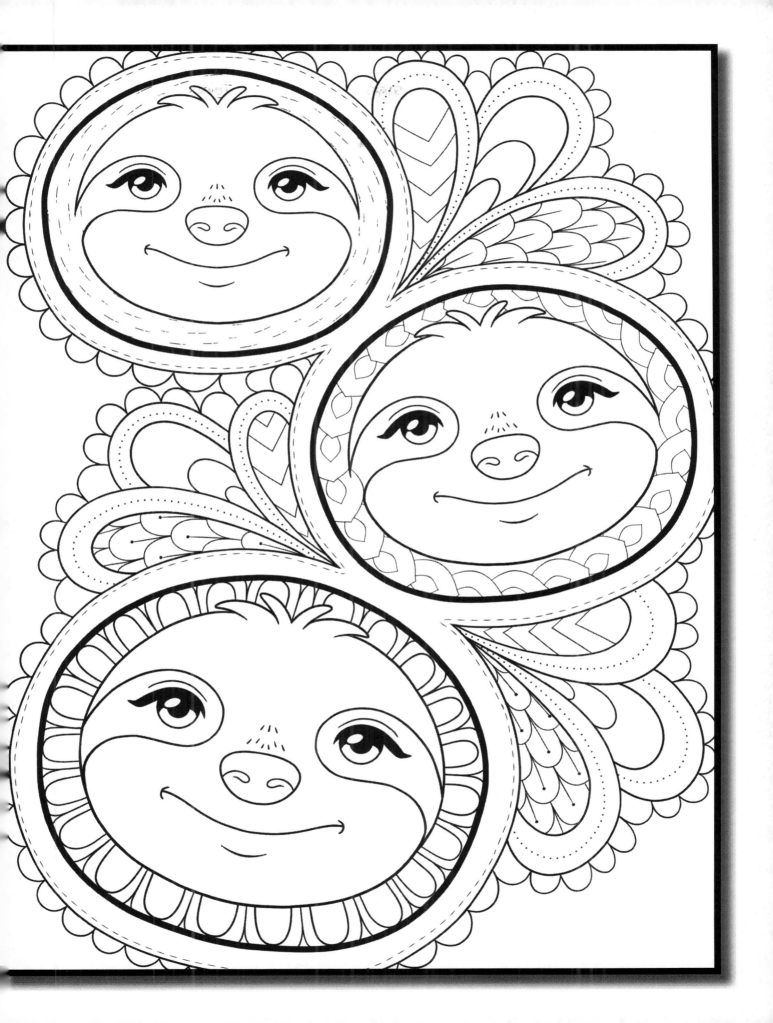

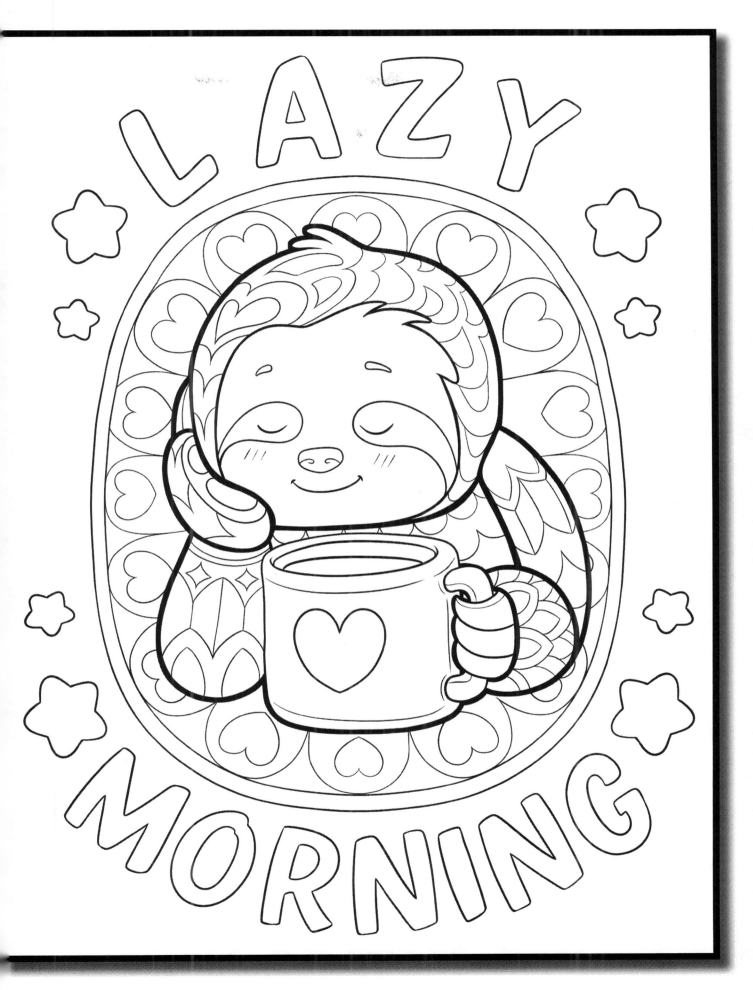

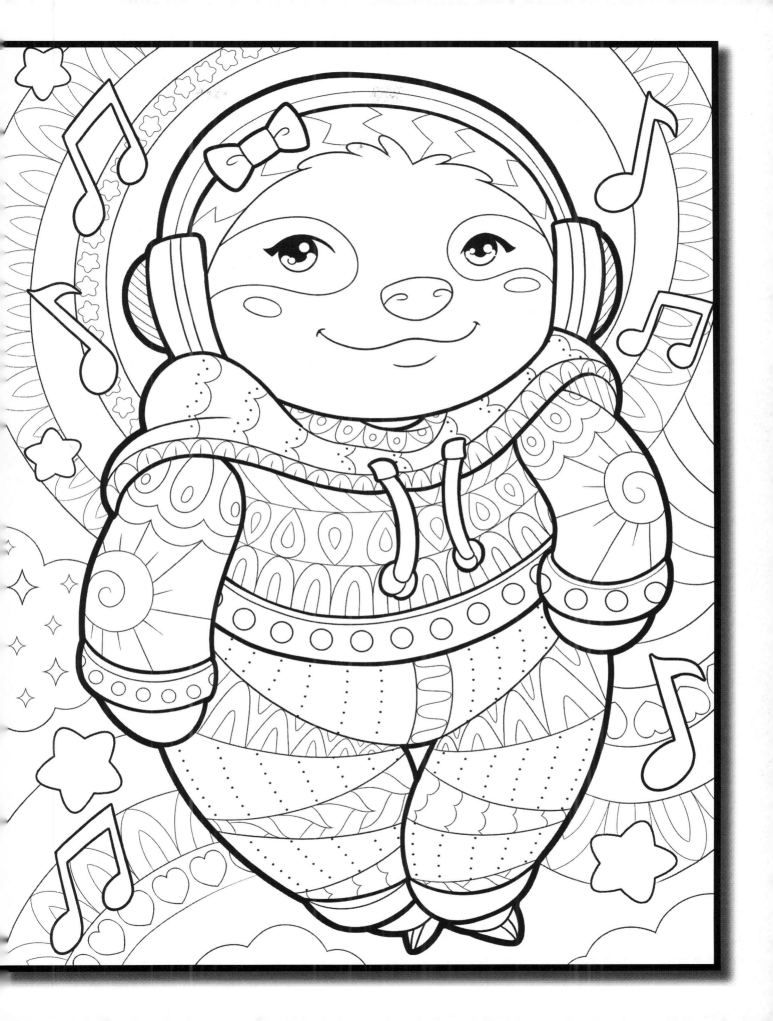

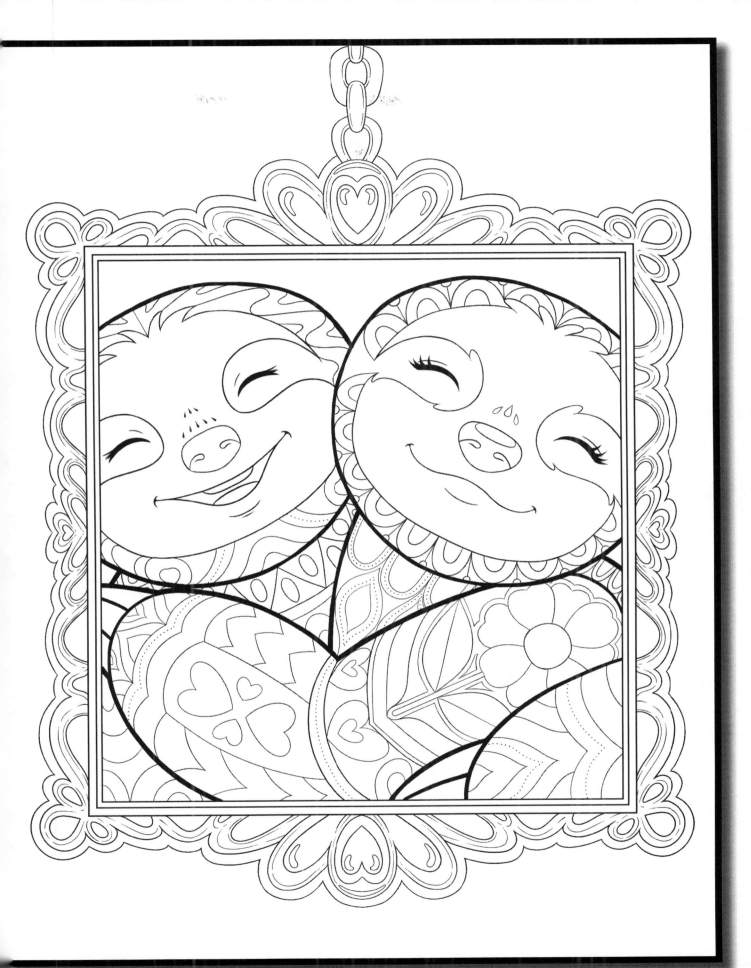

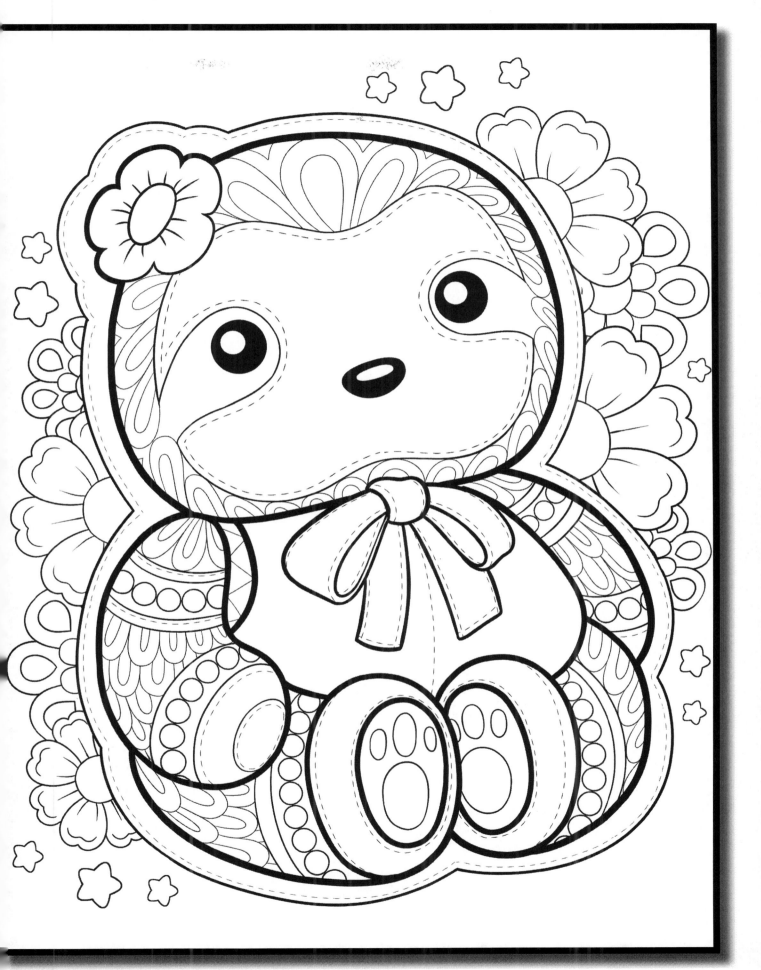

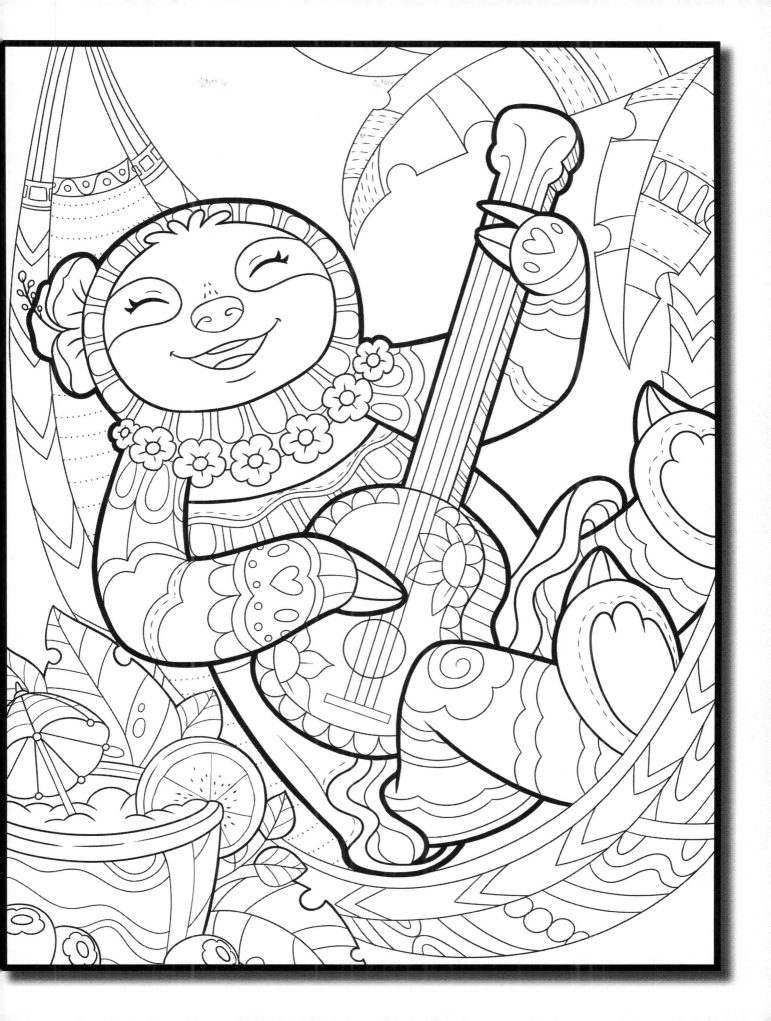

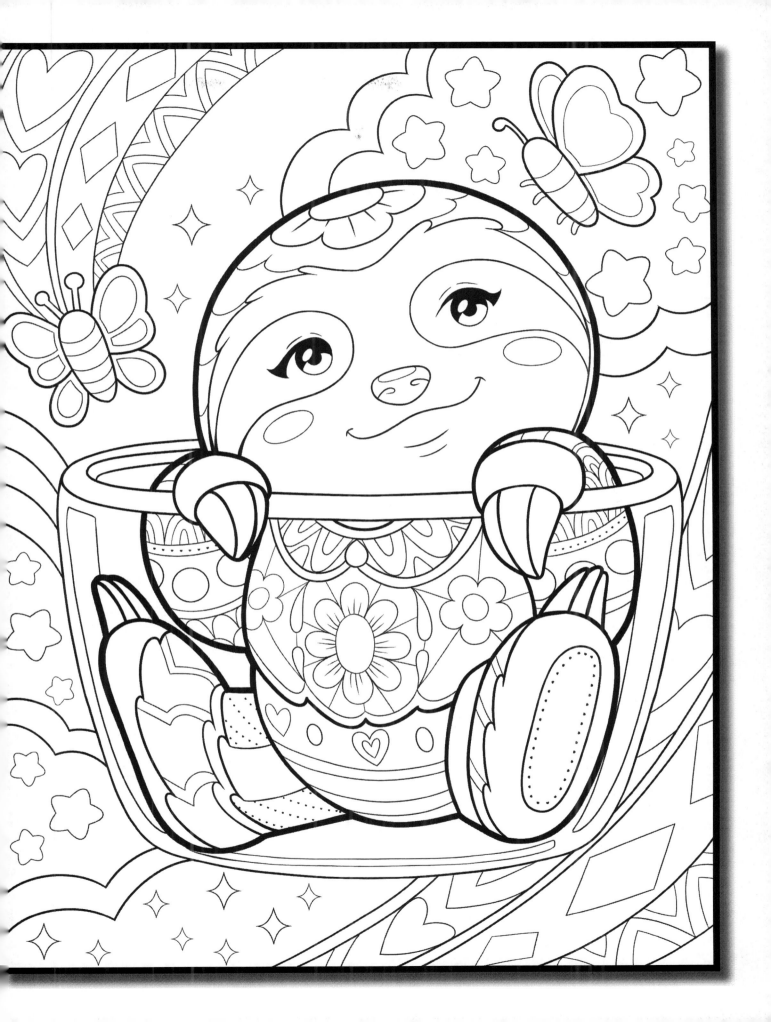

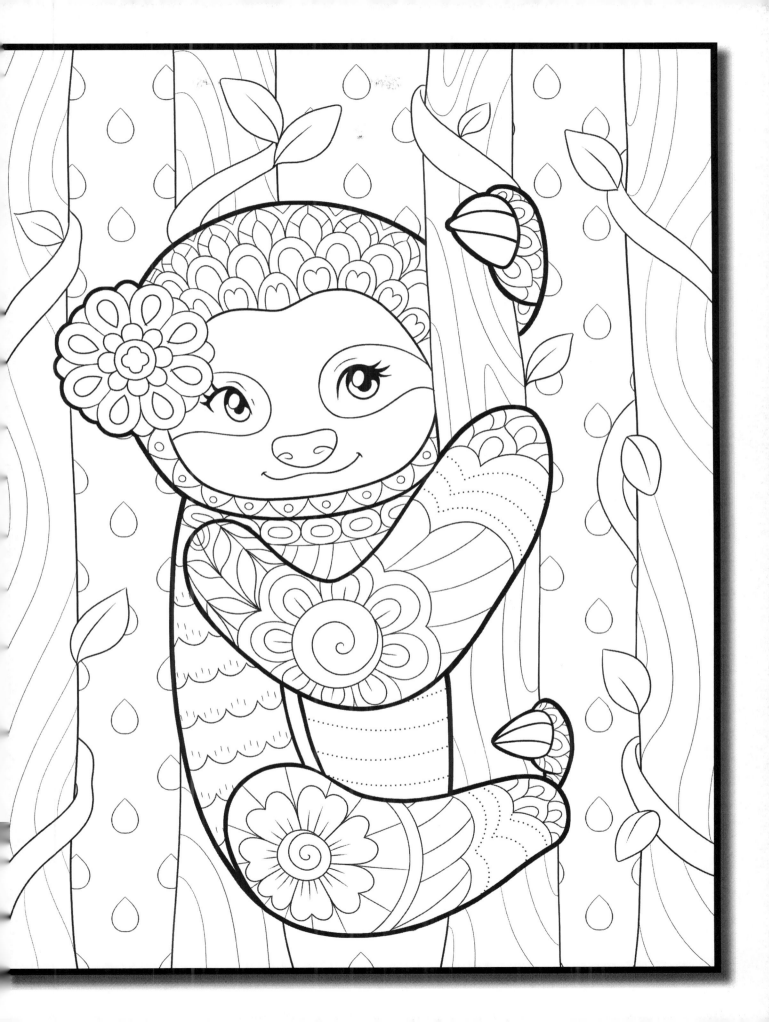

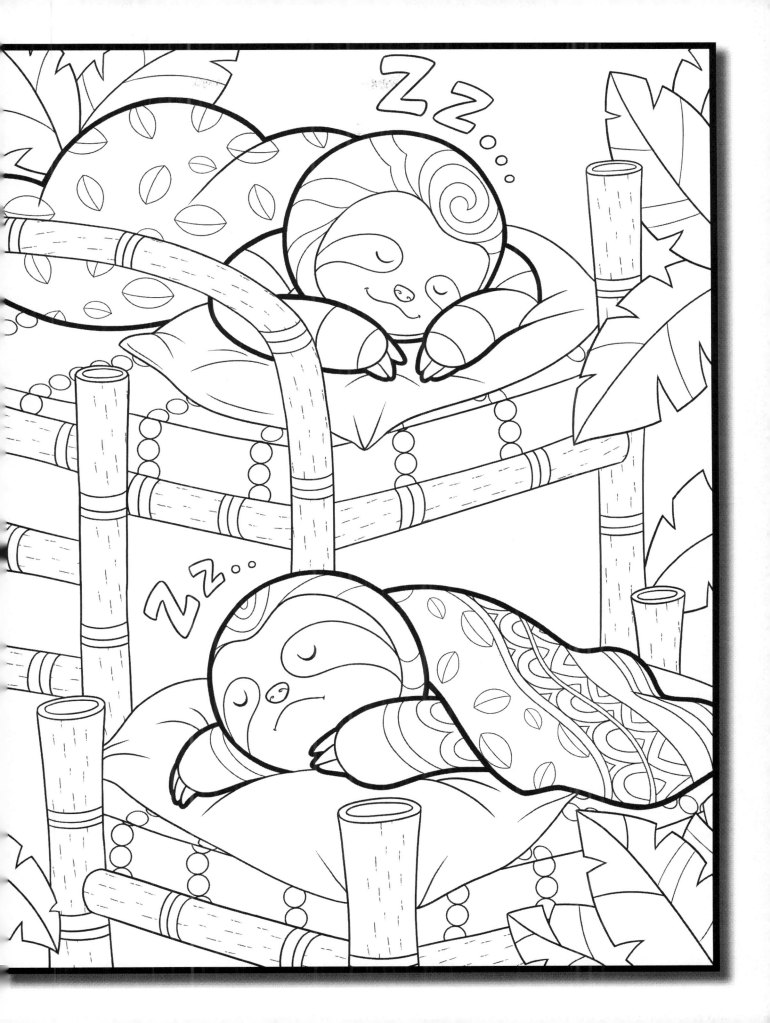

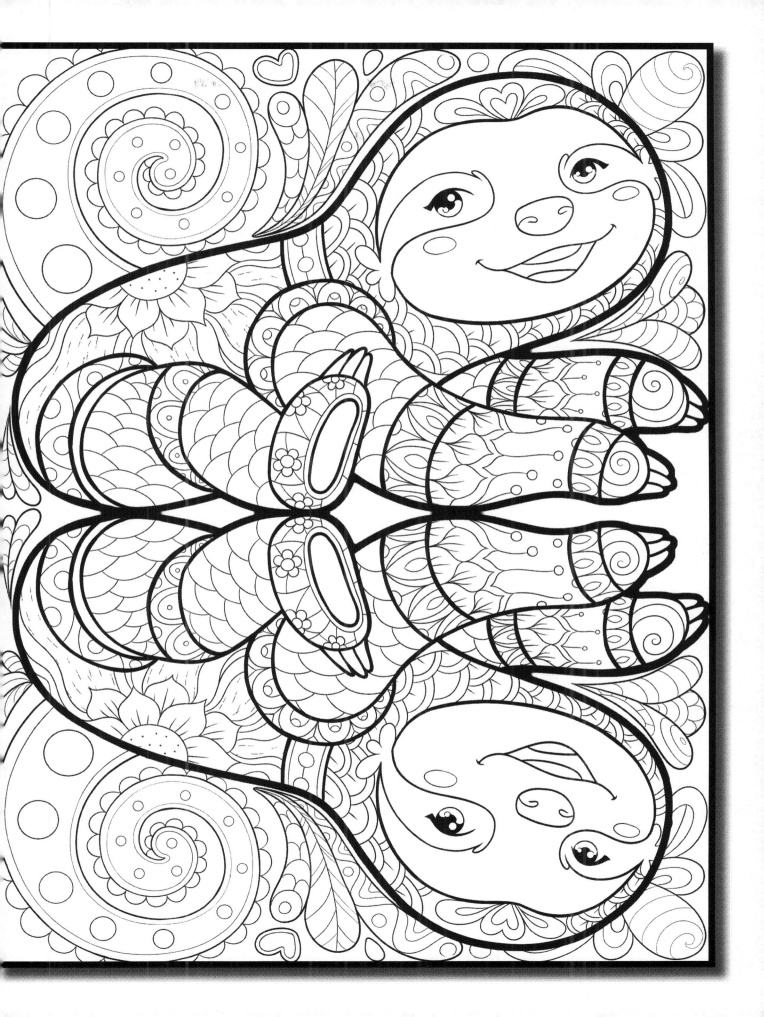

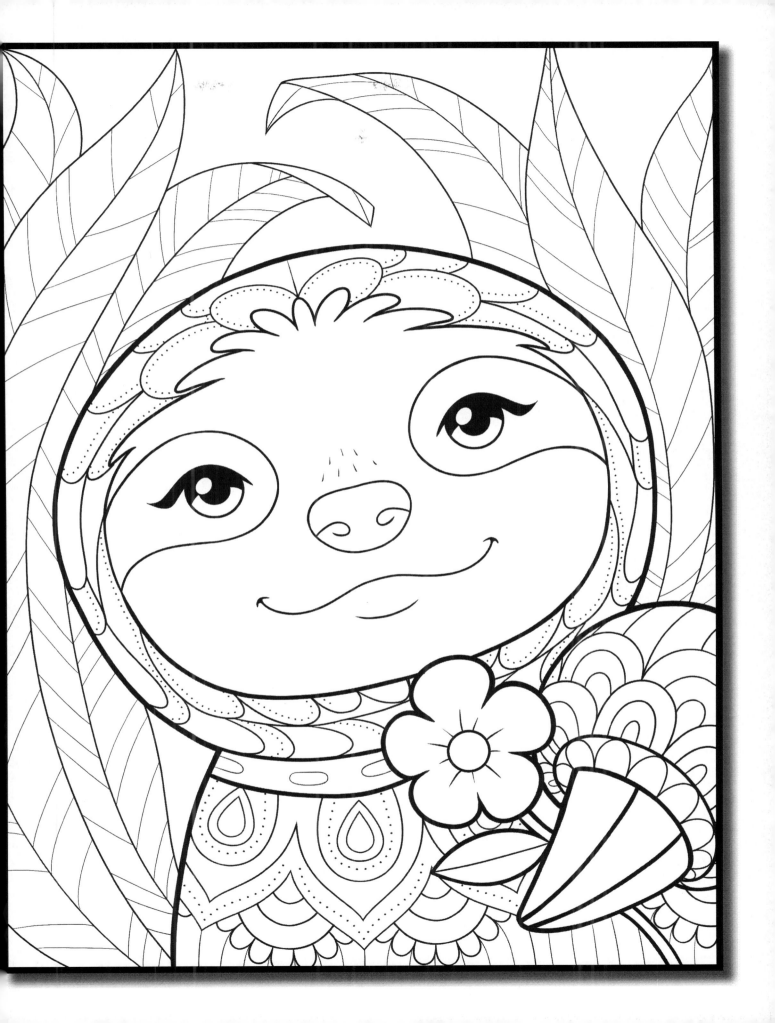

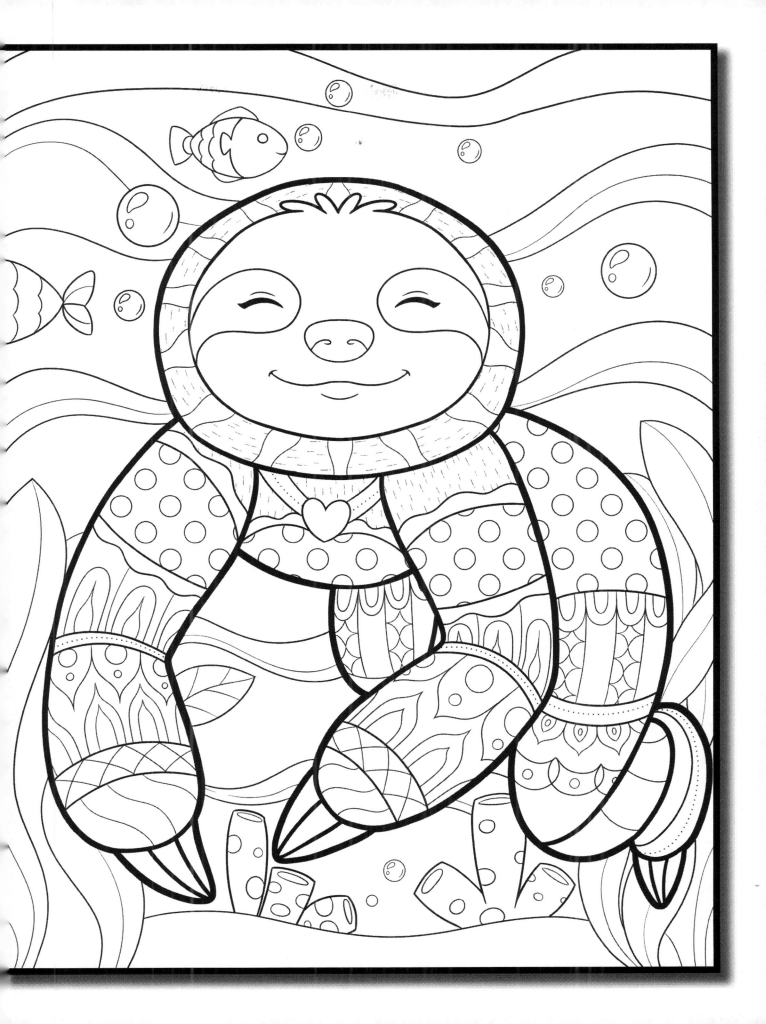

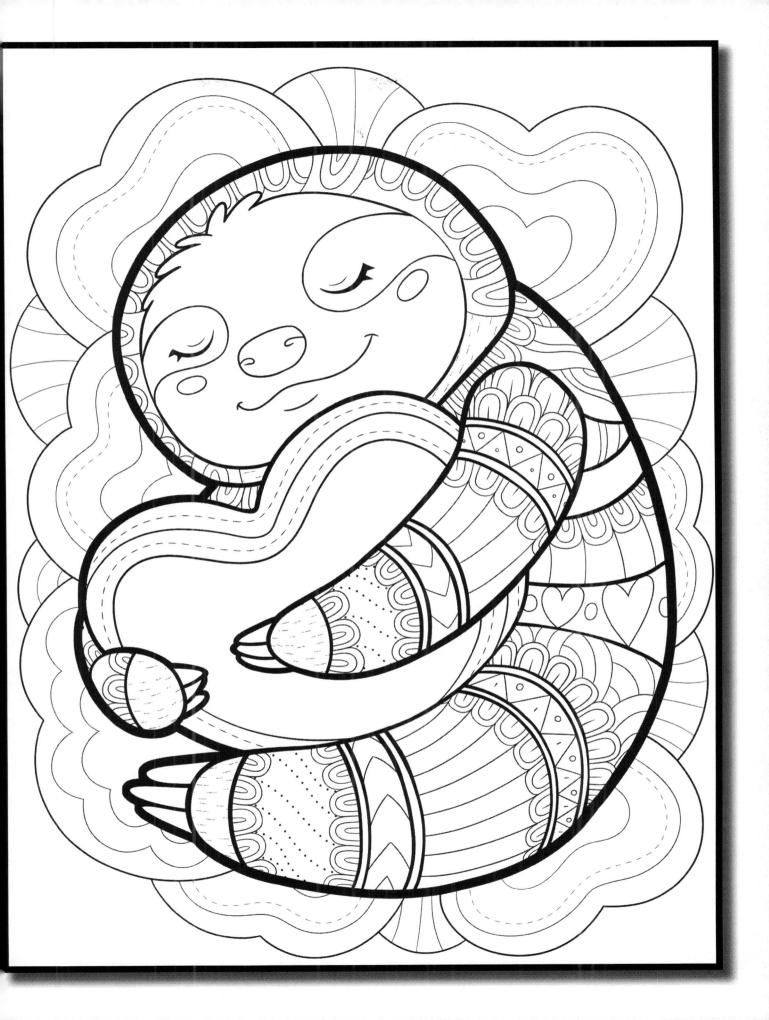

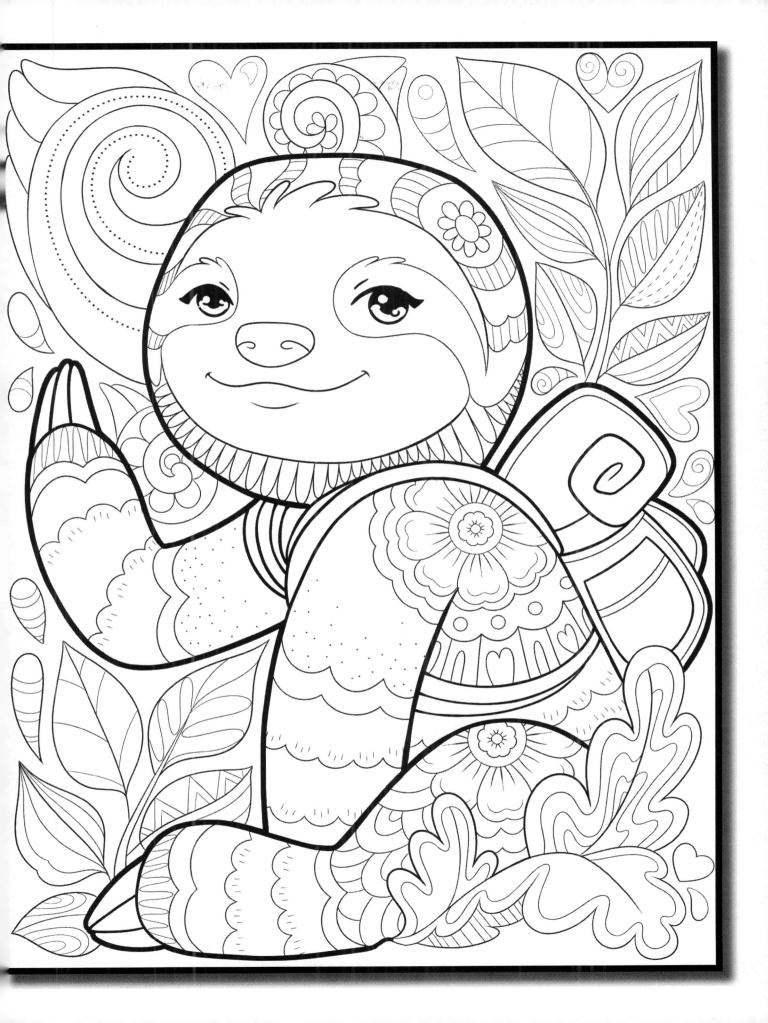

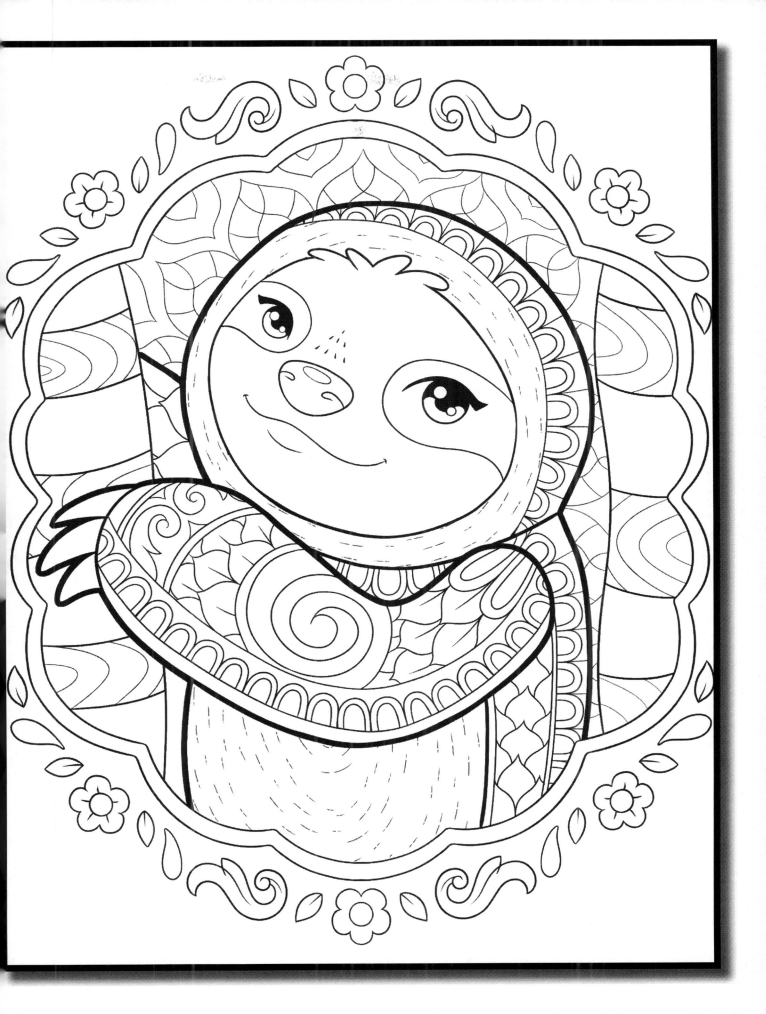

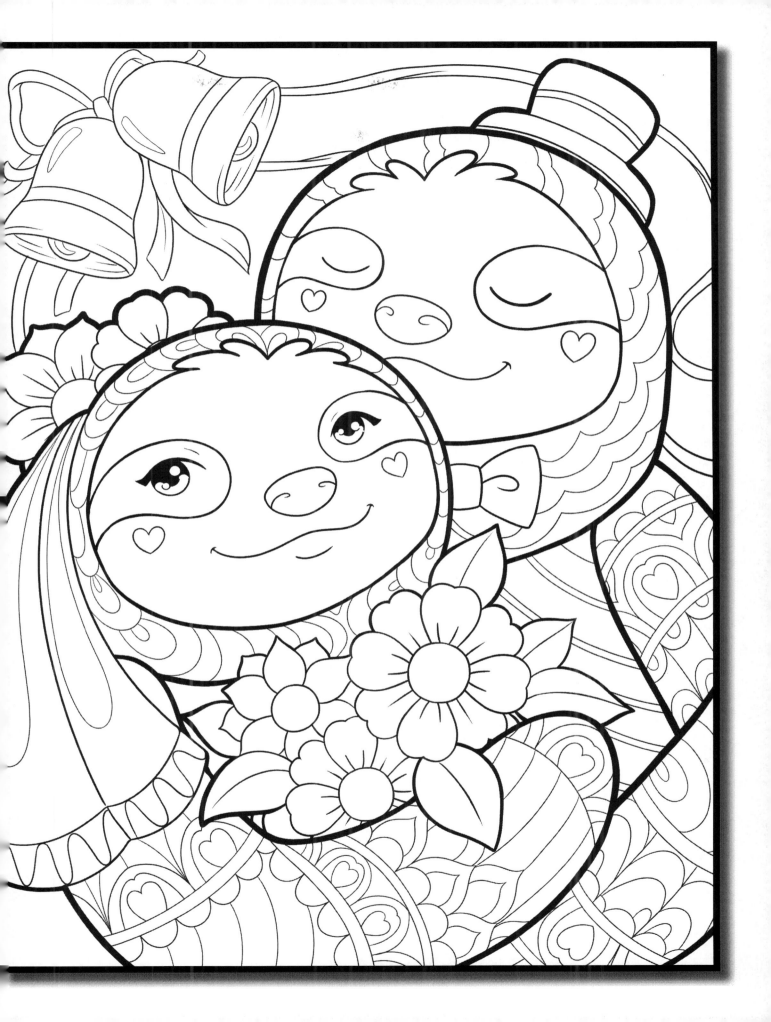

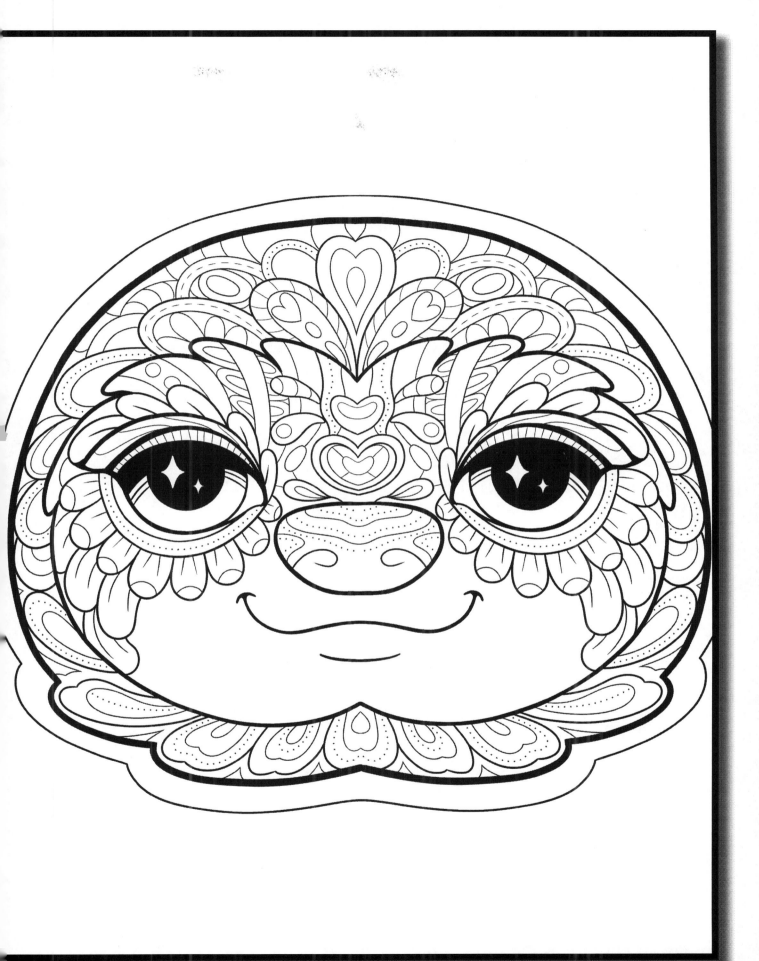

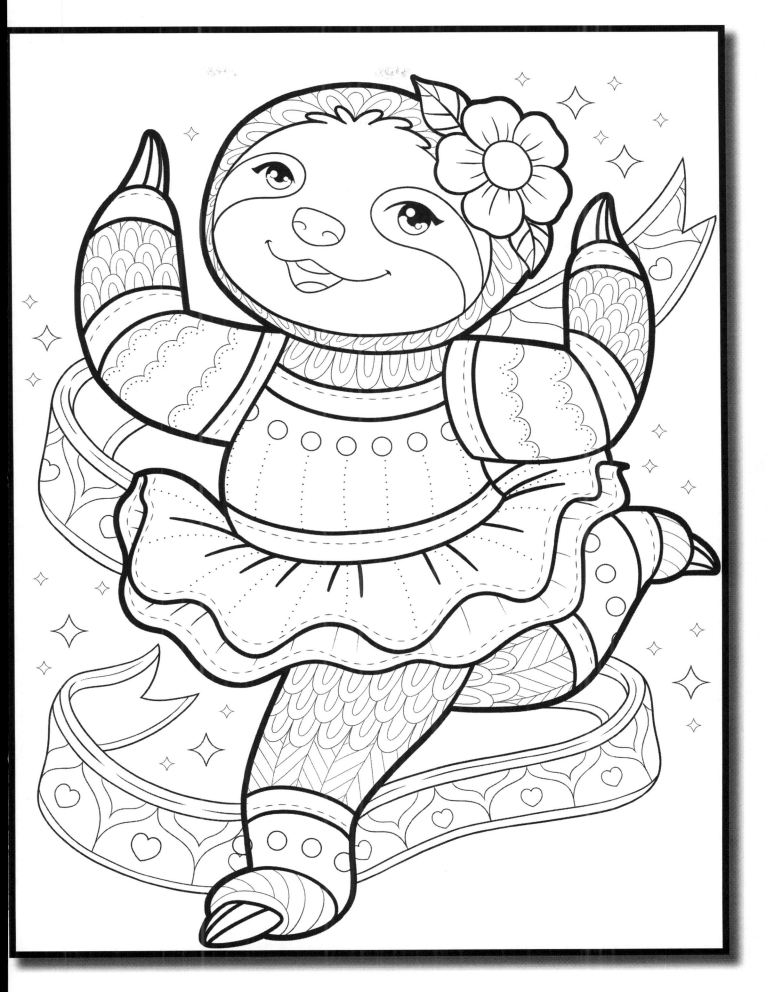

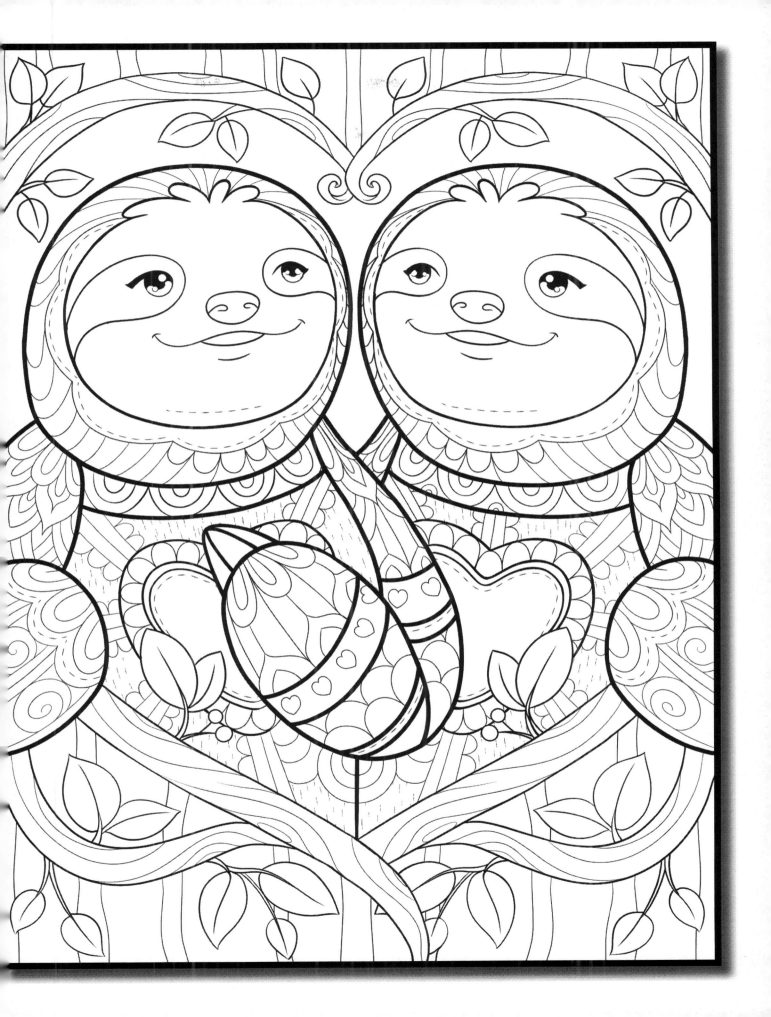

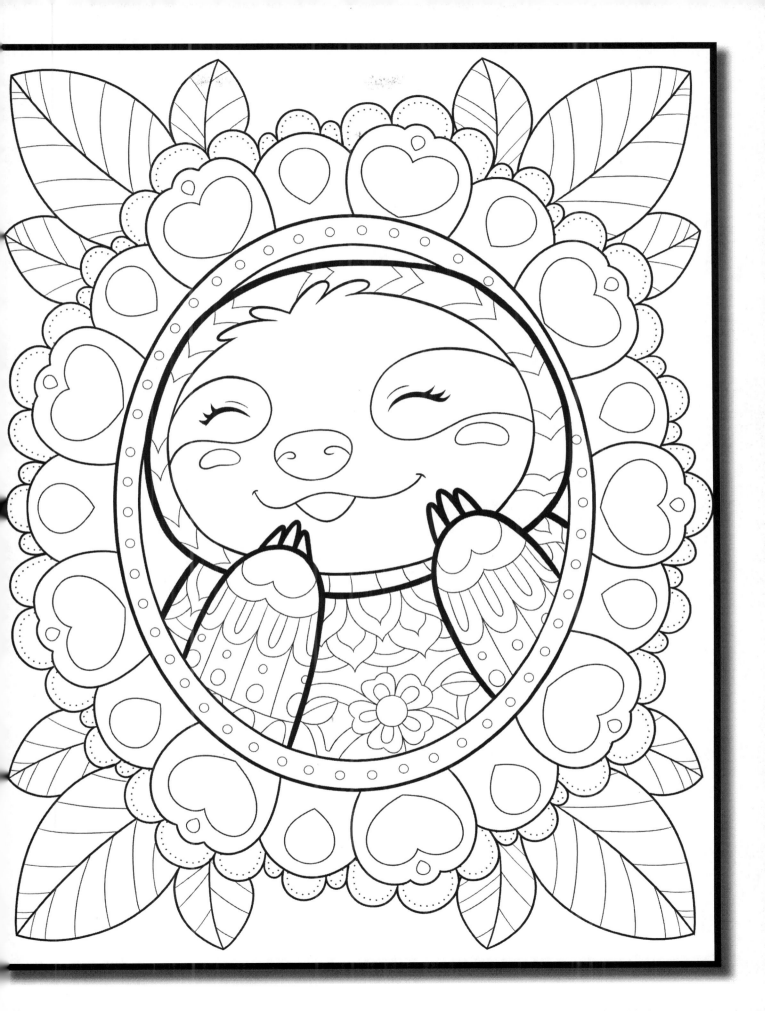

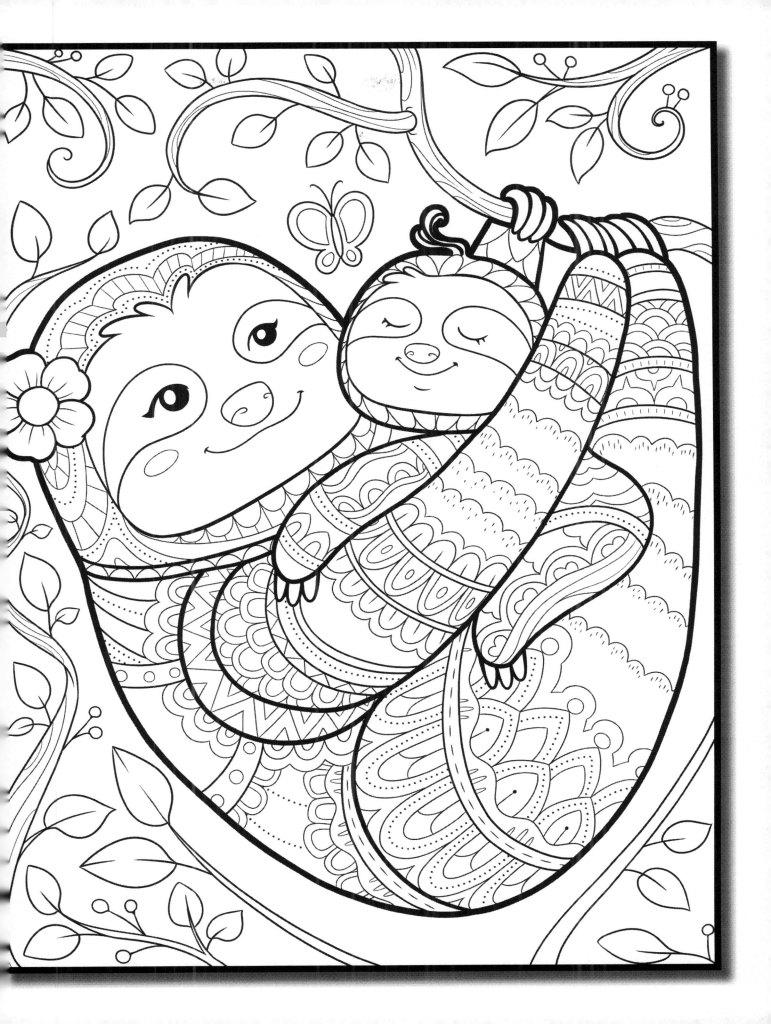

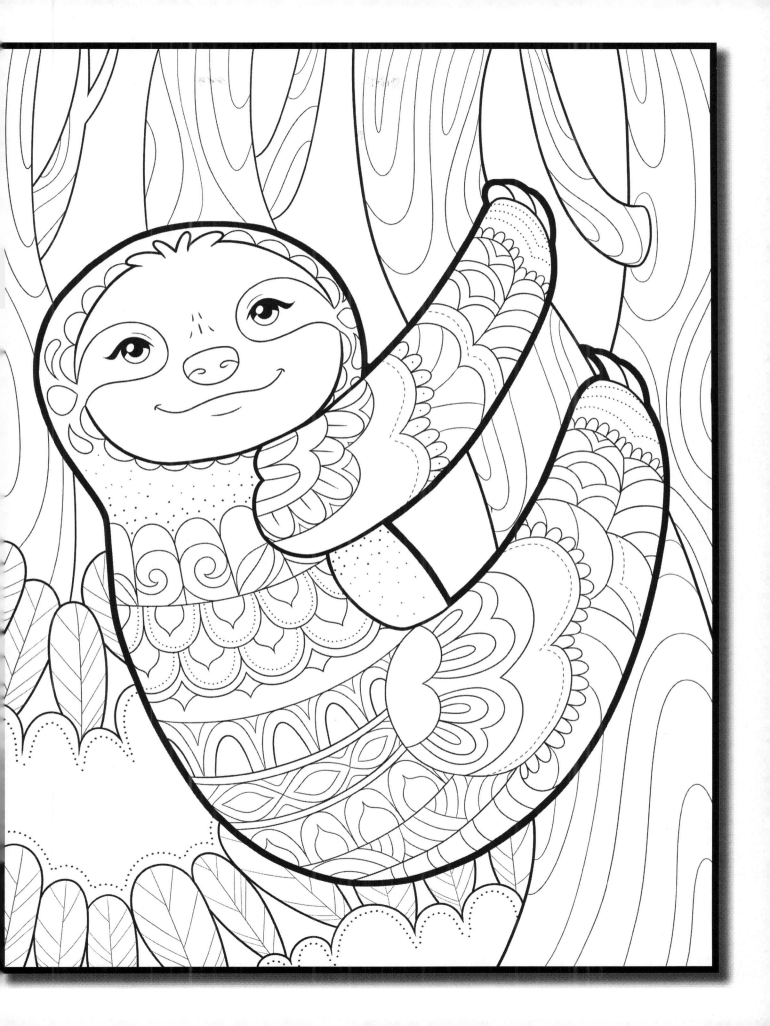

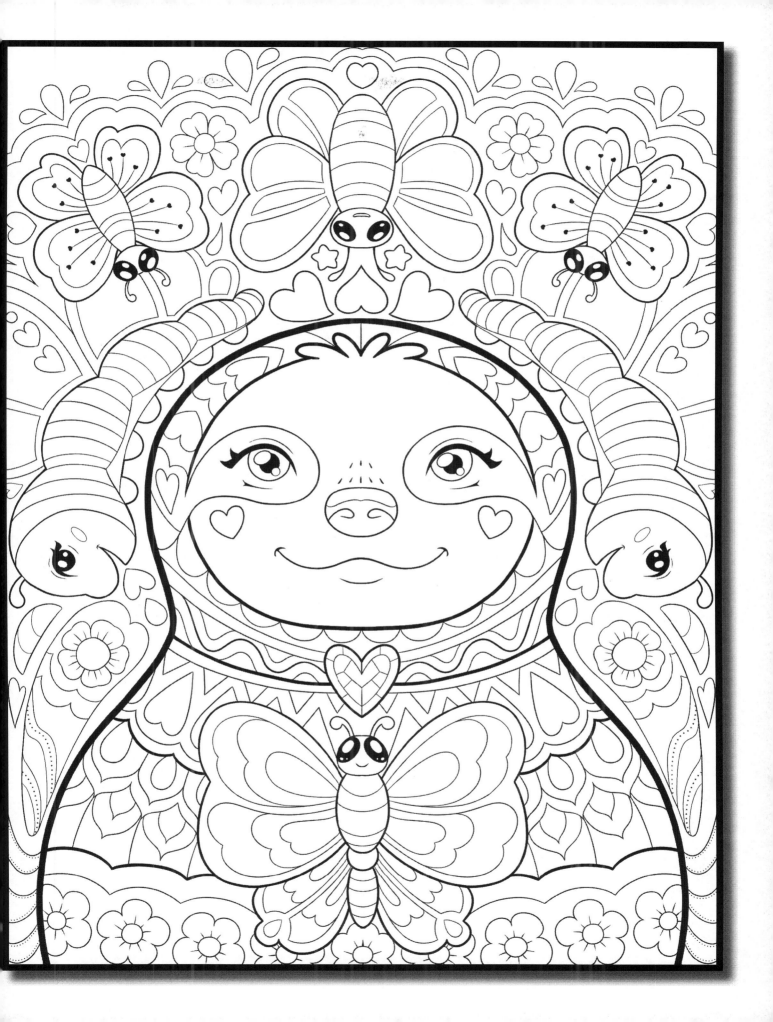

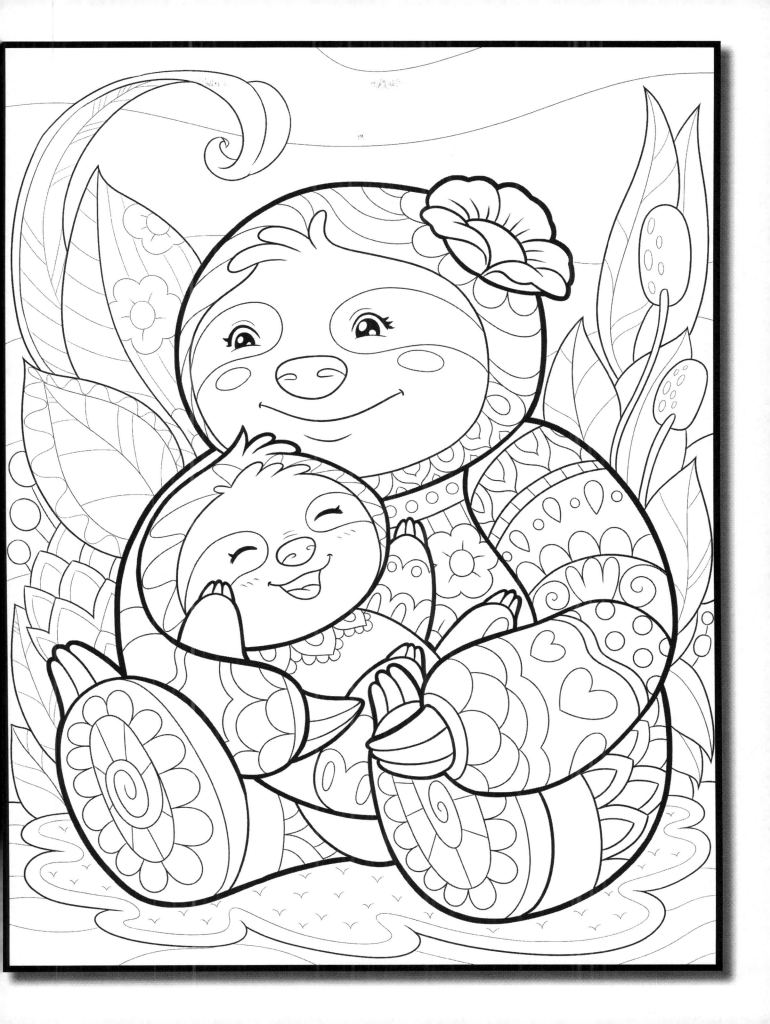

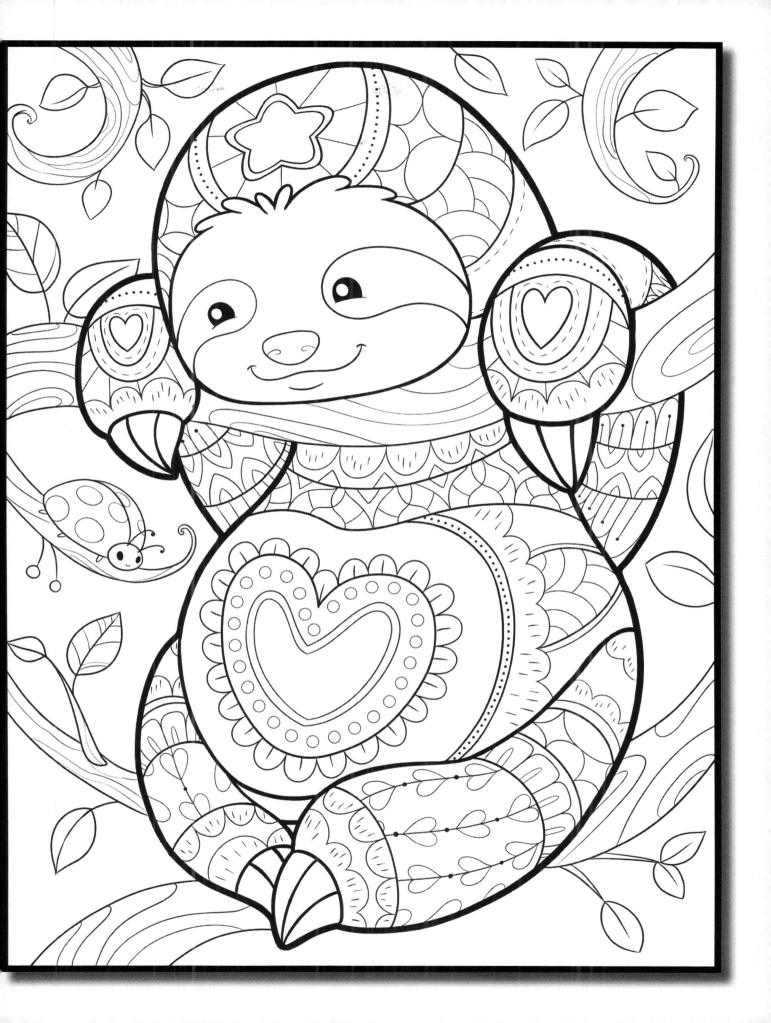

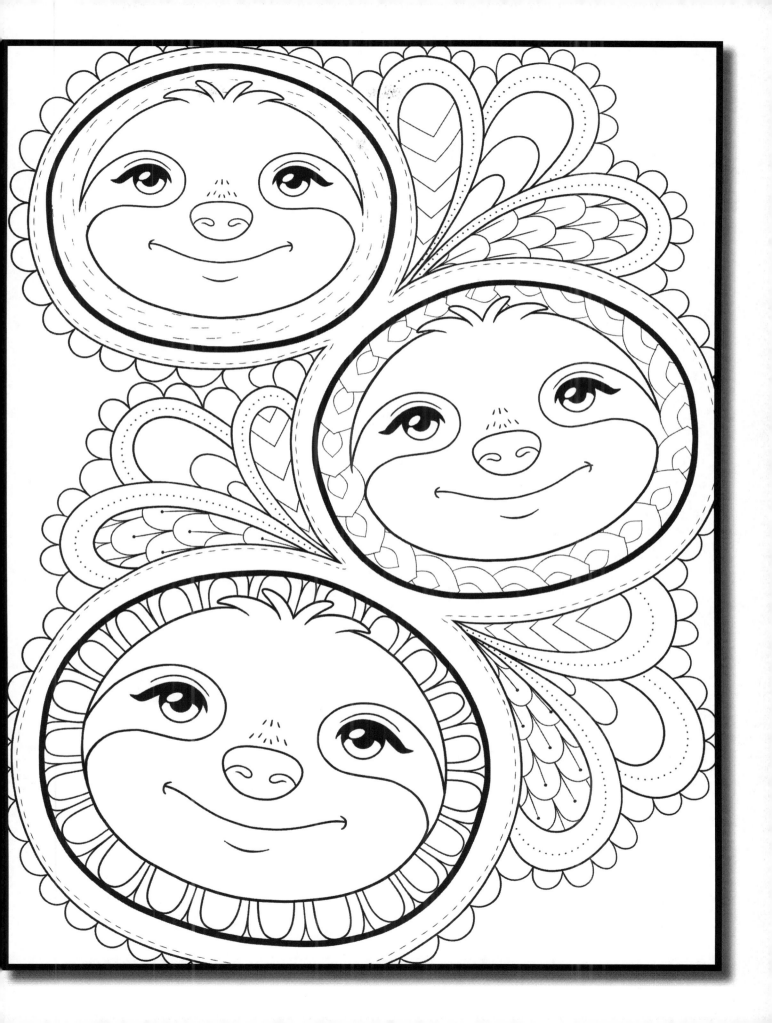

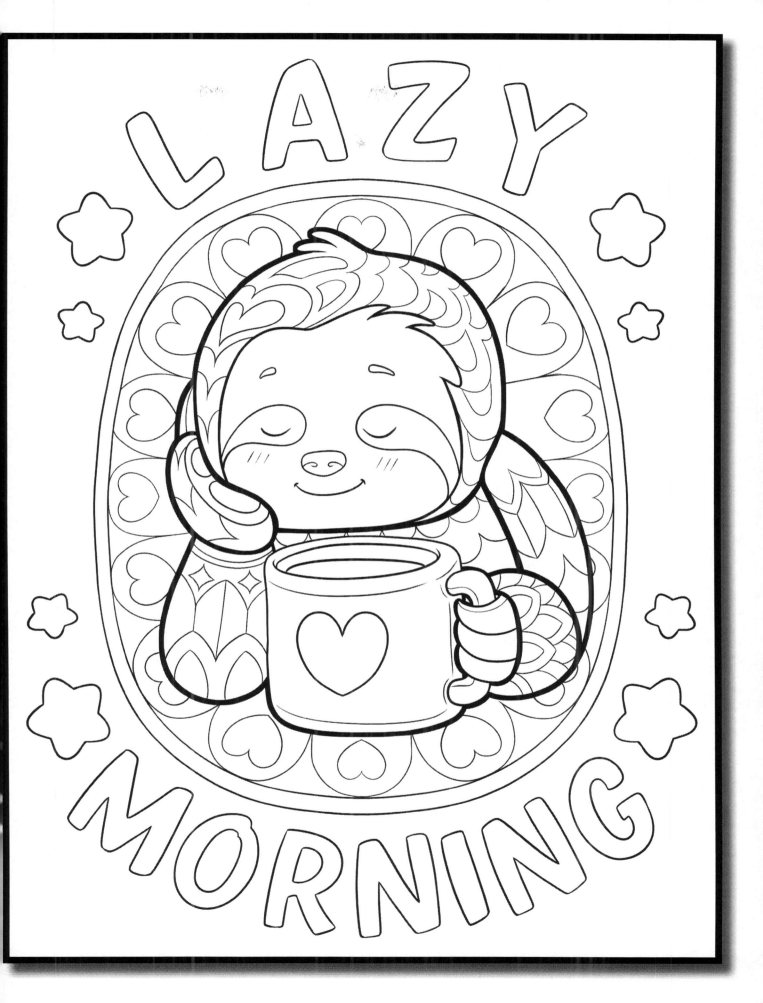

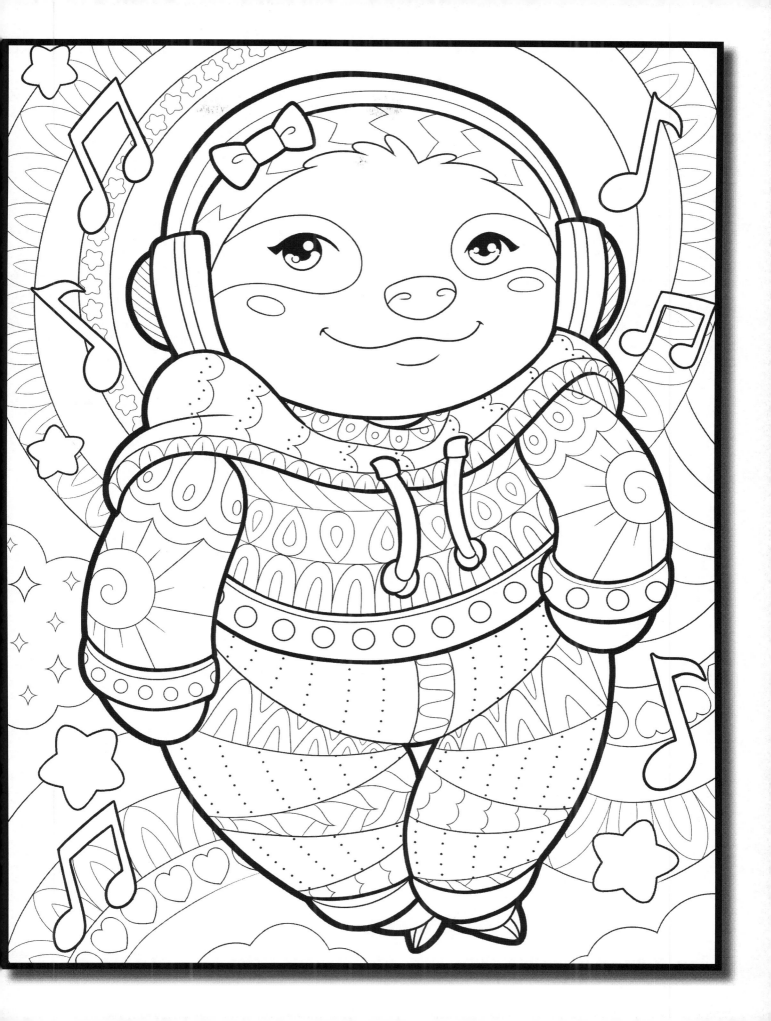

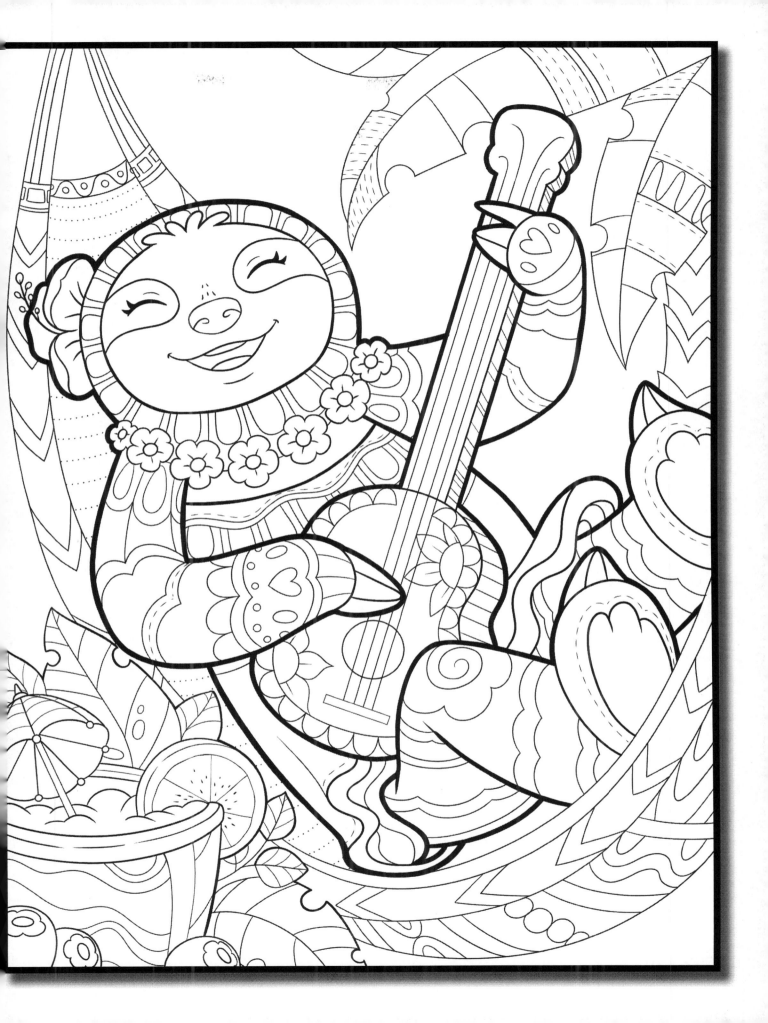

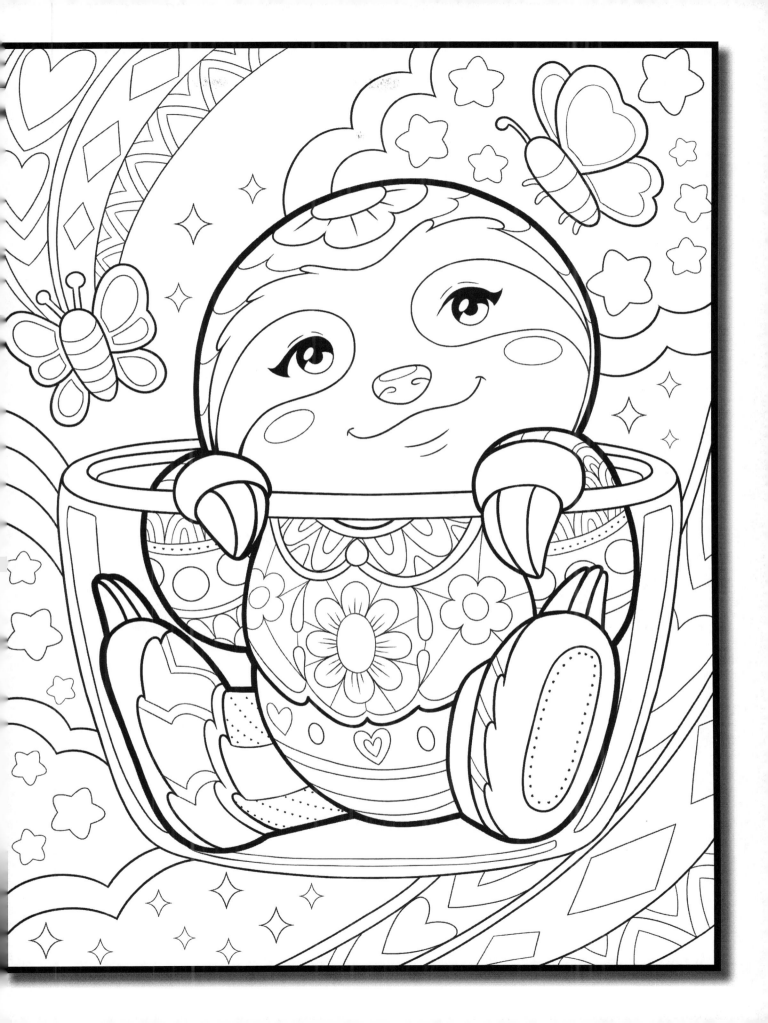

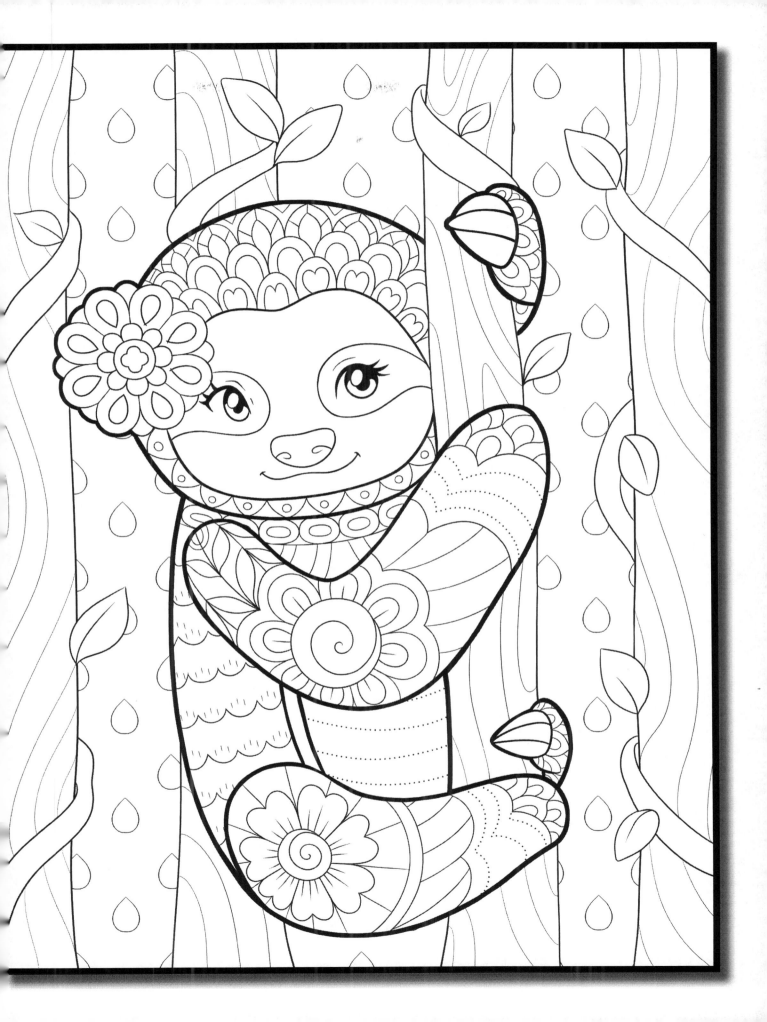

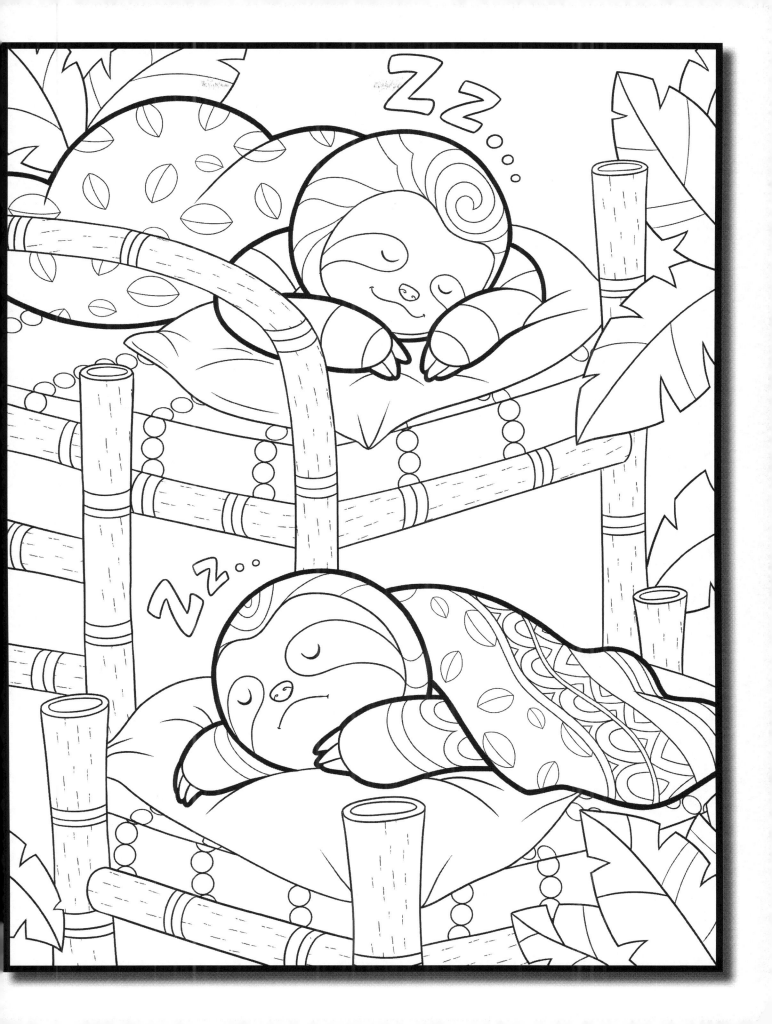

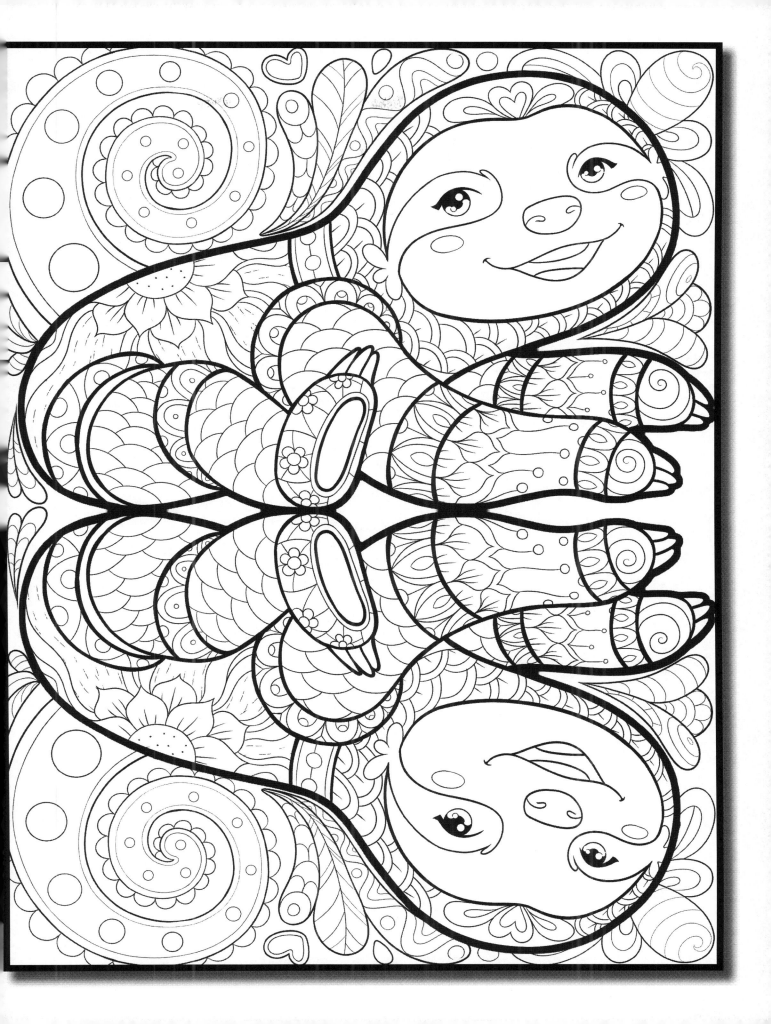

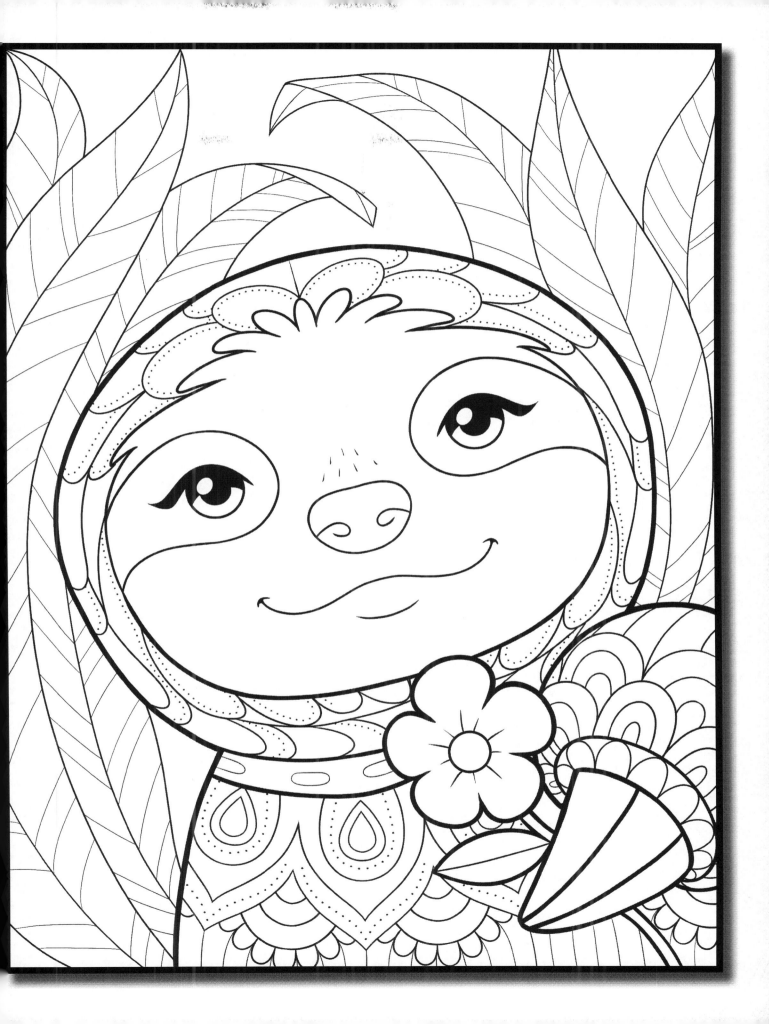

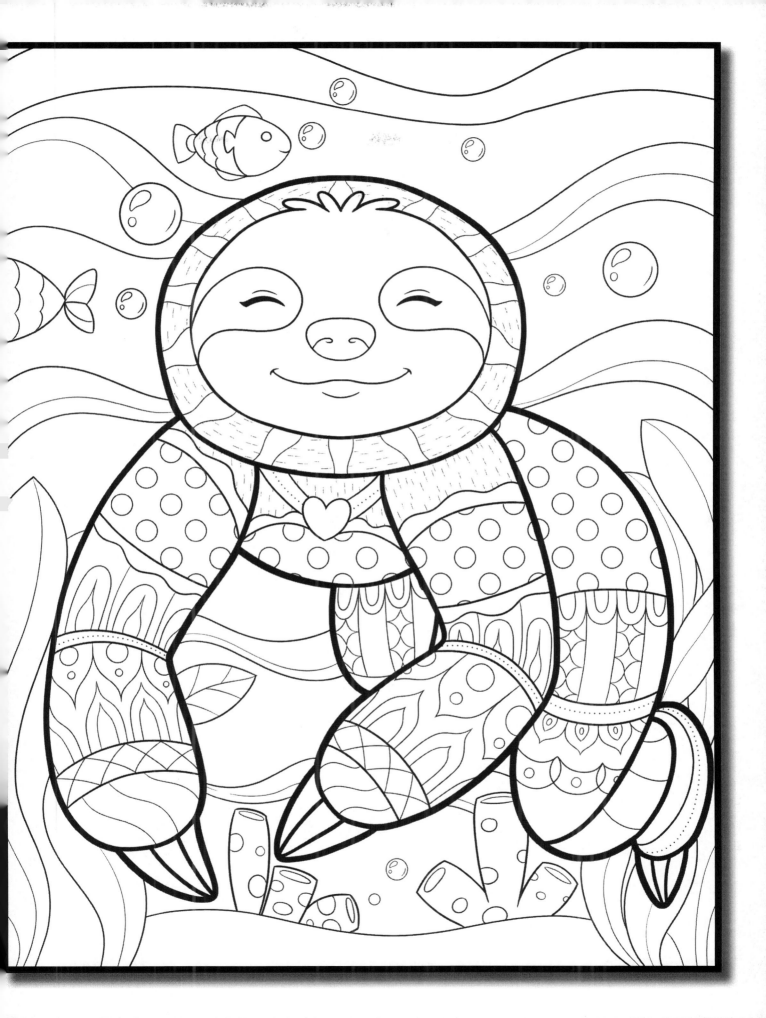

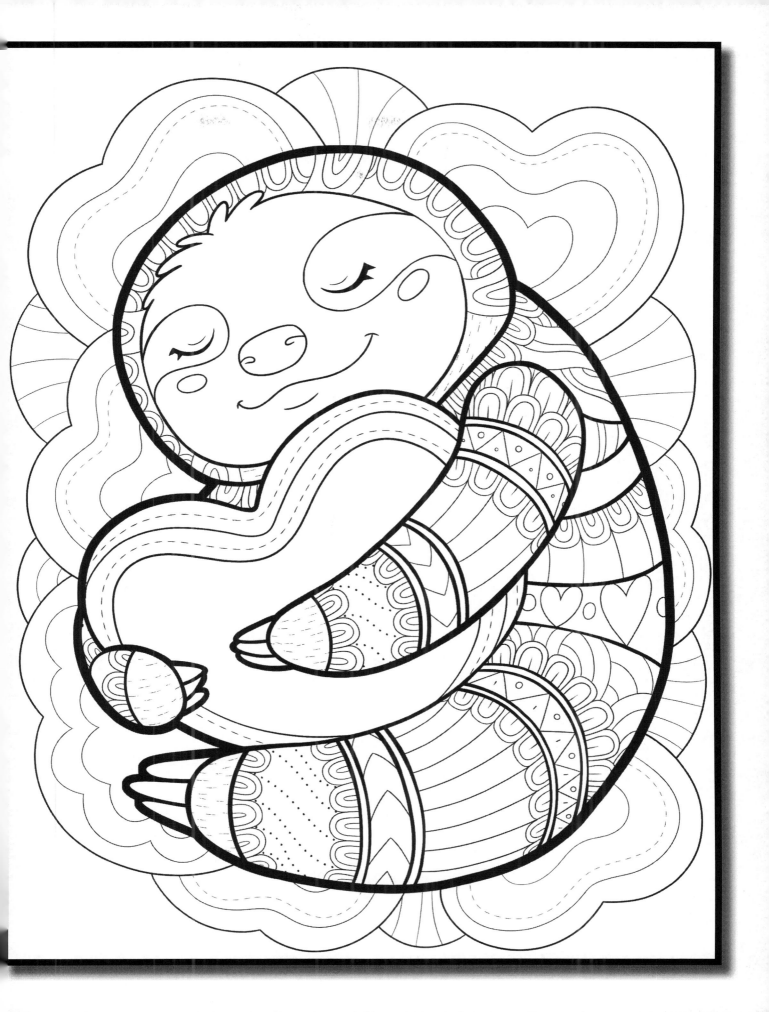

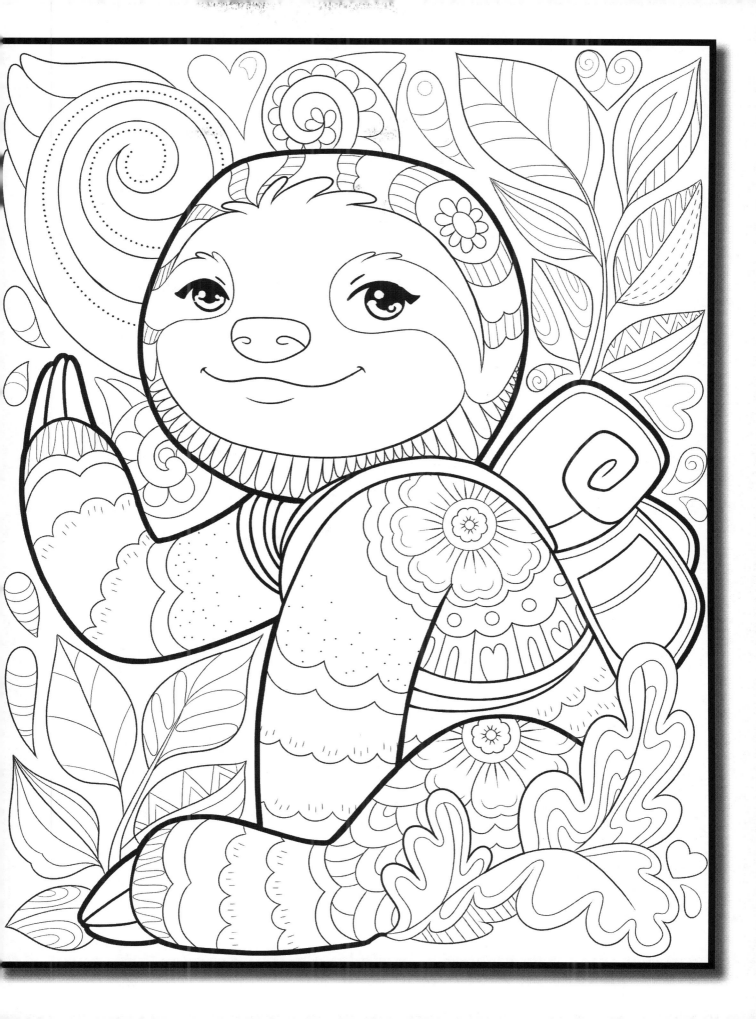

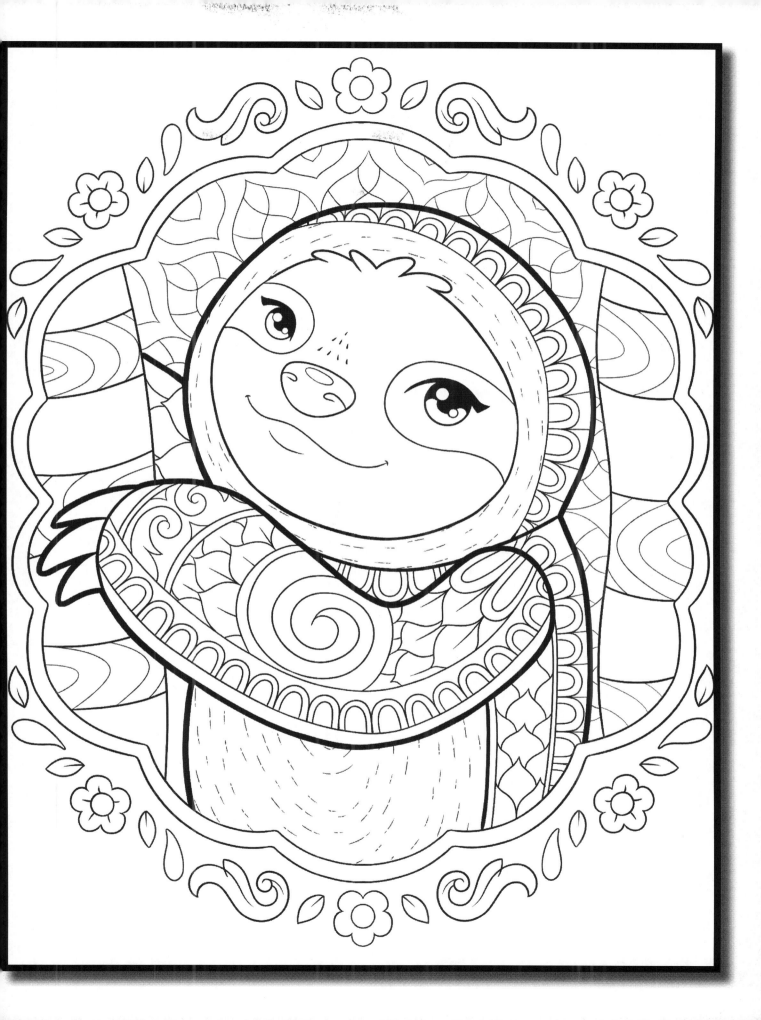

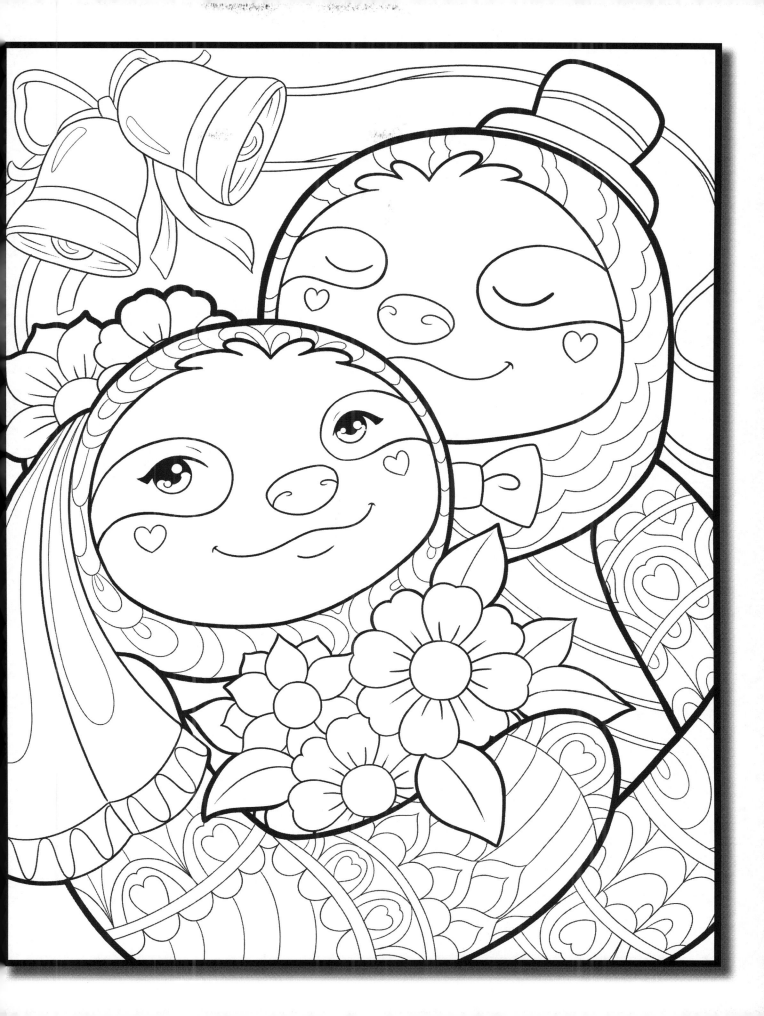

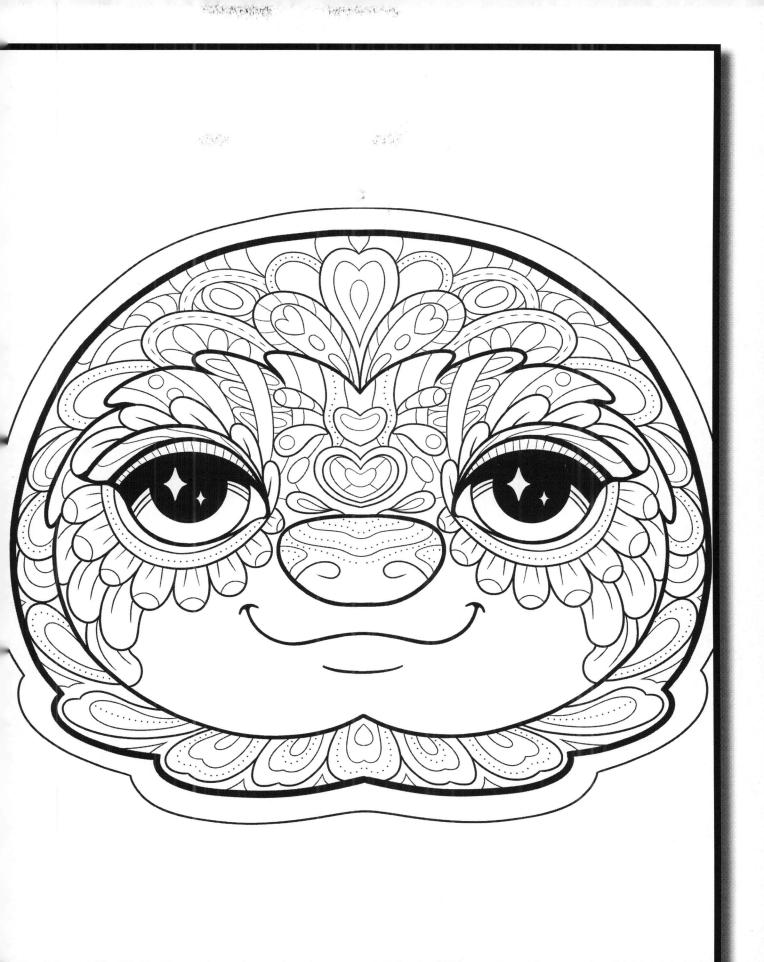

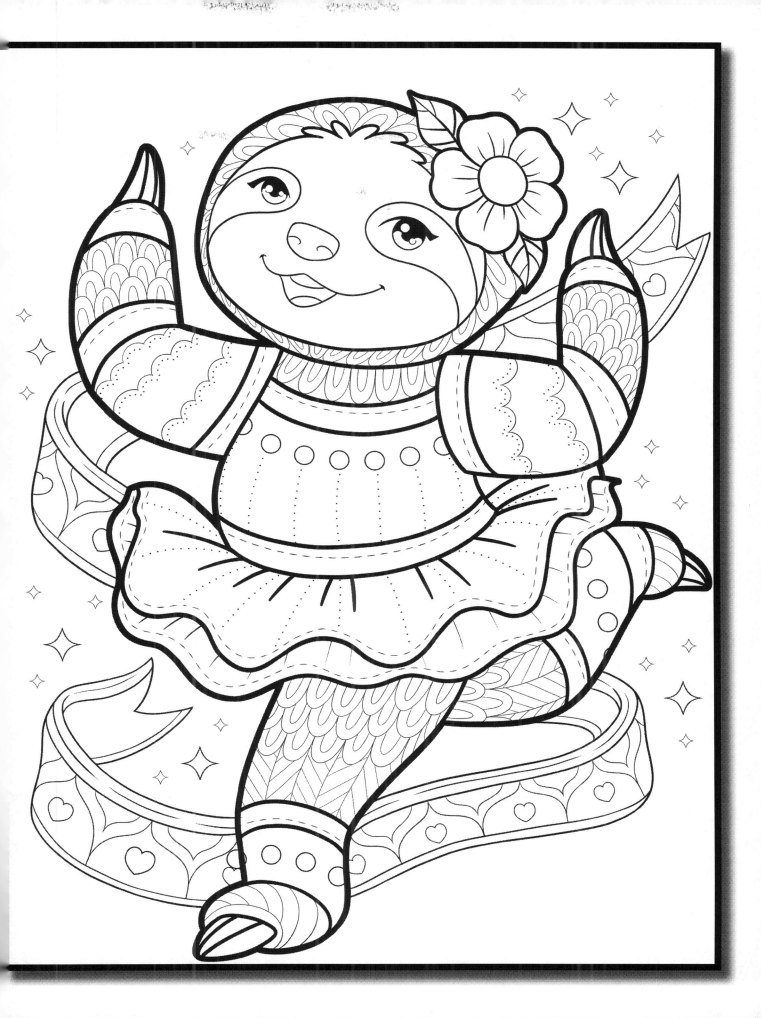

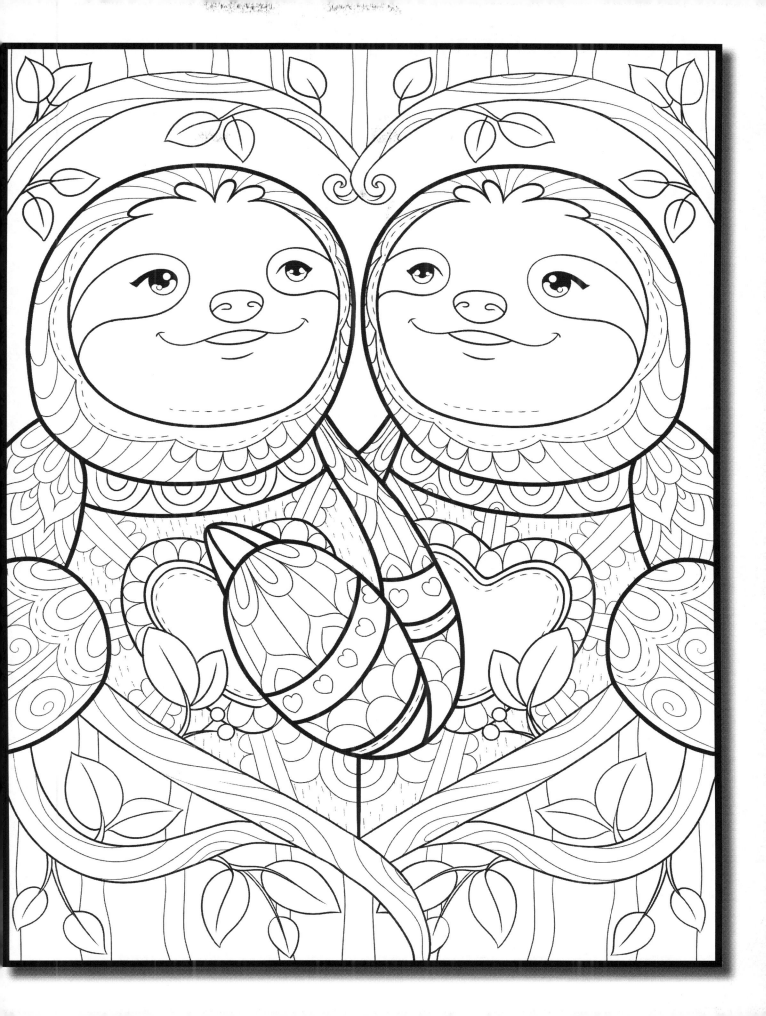

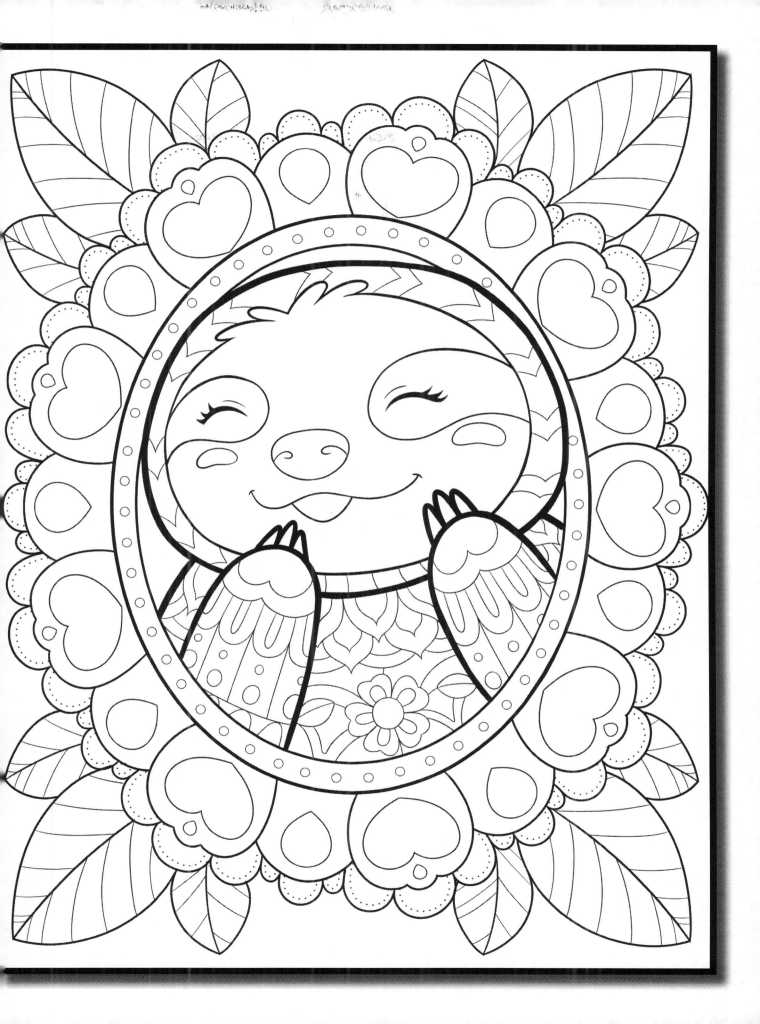

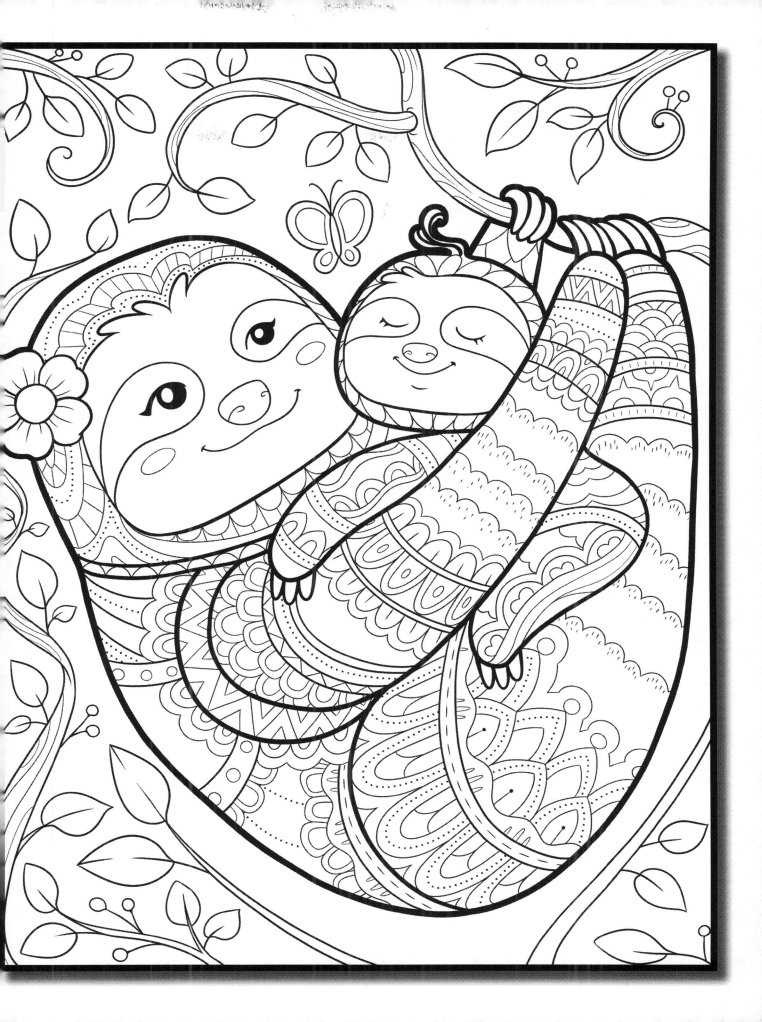

100 Amazing Patterns	Christmas #1	Dragons
100 Animals	Christmas #2	Dreams Come True
100 Flowers	Christmas #3	Easter
100 Magical Mandalas	Christmas Animals	Emoji
100 Magical Patterns	Christmas Flowers	Fairies
100 Magical Swirls	Christmas Mandalas	Fairies Grayscale
Adorable Owls	Christmas Patterns	Fantasy Adventure
Alice in Wonderland	Color Charts	Fantasy Collection #1
Animal Mandalas (2018)	Costume Cats	Fantasy Collection #2
Animals for Beginners	Country Cabins	Fantasy Grayscale
Anime	Country Cats	Fantasy Kids
Art Nouveau	Country Farm	Flower Bouquets
Autumn	Country Romance	Flower Girls
Baby Dragons	Cute Animals	Flower Mandalas
Beach Homes	Cute Animals #2	Flowers for Beginners
Beautiful Birds	Cute Cats	Forest Animals
Beautiful Flowers	Cute Christmas	Geometric Mandalas
Beginner Collection	Cute Fairies	Graffiti Animals
Chibi Animals	Cute Fairies Grayscale	Greatest Hits (2019)
Chibi Girls #1	Cute Unicorns	Greek Mythology
Chibi Girls #2	Cute Witches	Halloween
Chibi Girls Grayscale	Dark Fantasy	Haunted House
Chibi Girls Horror	Delicious Food	Hidden Garden

LEAVE YOUR AMAZON REVIEWS

Show your support for Jade Summer and help other colorists discover our artwork.

Simply find this book on Amazon, scroll to the reviews section, and click "Write a customer review".

Thank you for your purchases and reviews.

BONUS PAGE
STUFFED ANIMALS

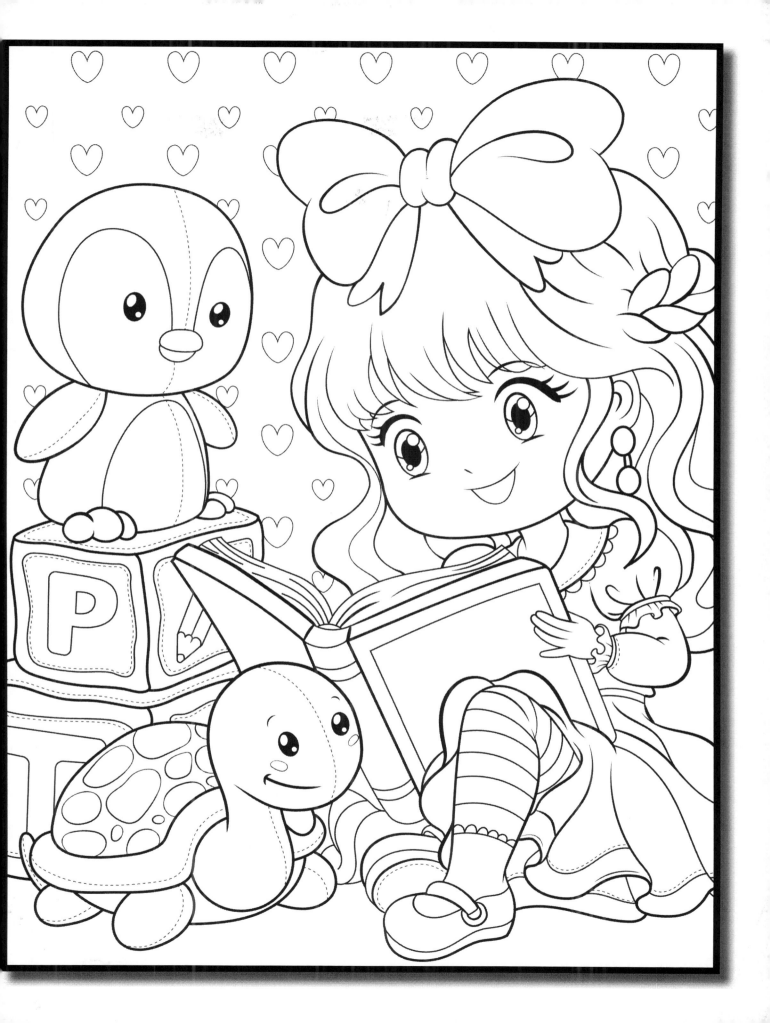

Made in the USA
Columbia, SC
30 November 2020